Patricia — Here's to good times + great beers!

Charlottesville

BEER

BREWING IN JEFFERSON'S SHADOW

LEE GRAVES

Photography by Jennifer Pullinger

D1043122

AMERICAN PALATE

Published by American Palate
A Division of The History Press
Charleston, SC
www.historypress.net

Copyright © 2017 by Lee Graves
All rights reserved

First published 2017

Manufactured in the United States

ISBN 978.1.46711.956.6

Library of Congress Control Number: 2016950688

CONTENTS

ACKNOWLEDGEMENTS

U ndertakings such as this rely on the cooperation, expertise and patience of a diverse cast of characters, and I have been blessed to enjoy the aid and support of some truly exceptional people.

As with my previous book, *Richmond Beer: A History of Brewing in the River City*, my talented wife, Marggie, provided expert copy editing and consistent enthusiasm. My best friend, Les Strachan, also continued the role he has occupied for four-plus decades, sharing good times and great beers. I credit his love of flavorful beer with igniting my passion many years ago. My daughters, Helen Marie and Cassie, have been patient partners in this journey, as has my son-in-law, Don Madden.

One person deserves particular thanks. While I was writing this book, I rented a secluded cottage at the end of Poorhouse Road, a gravel lane that wound through a hollow off U.S. 29. It felt remote yet was within fifteen minutes of downtown Charlottesville. Only two other houses were occupied on this road, and one belonged to Lucia "Cinder" Stanton. As former director of research at Monticello and author of several books, including *Free Some Day: The African-American Families of Monticello*, Cinder enjoys a status that one Monticello official described as "legendary." Had I been fully aware of her stature, I would have been intimidated to meet her. But she has been gracious and generous in sharing resources and helping me through the complexities of Jeffersonian history and lore. I can't thank her enough.

It's important also to acknowledge the folks at The History Press, particularly my commissioning editor, Banks Smither, for keeping me on

target. My faithful photographer-collaborator, Jennifer Pullinger, also has helped immeasurably with her excellent eye for riveting images and her knowledge of social media.

Thanks go to several other individuals. Frank Clark, master of historic foodways at Colonial Williamsburg, has played an invaluable role in fueling interest in the history of beer and its role in culture. I also owe a tip of the hat to Susan Kern at the College of William and Mary, Mary Thompson at Mount Vernon and Sean O'Brien at Montpelier for sharing research related to their institutions. And my good friend David Goode of Piedmont Hops provided insight into the value of slave-grown hops.

The research for this book was expedited considerably by several organizations: the Thomas Jefferson Foundation at Monticello, the Albemarle Historical Society, the Virginia Historical Society, the Albert and Shirley Small Special Collections Library at the University of Virginia, the Library of Virginia and the Jefferson-Madison Regional Library in Charlottesville.

On a national level, the Brewers Association, based in Boulder, Colorado, has been an invaluable resource for data about craft brewing and trends in the industry. Julia Herz, national craft beer program director; Bart Watson, chief economist; and, of course, Charlie Papazian (see chapter 6) have been tremendous not only for their knowledge and resources but also for their friendliness and accessibility.

Last, and certainly not least, to the community of professional brewers, homebrewers, beer lovers, beer geeks, beer reps, hops growers, taproom owners, beer service folks (yes, you behind the bar), beer writers and beer readers in Charlottesville and beyond—I will be forever grateful for your interest, indulgence, help and support.

Thanks to all!

INTRODUCTION

On July 4, 1826, John Adams lay on his deathbed in rural Quincy, Massachusetts. Many things ran through his mind, but one thought occupied his final moments: his relationship with Thomas Jefferson. Once friends, then rivals and adversaries, they had rekindled their relationship late in life. As Adams died, his alleged final words were, "Thomas Jefferson survives."

In fact, Jefferson had died five hours earlier at Monticello, his mountaintop estate in Albemarle County. In truth, though, Adams's words were prophetic. Thomas Jefferson survives today. His legacy looms large over Charlottesville in particular and the nation as a whole. Research through the centuries has revealed layers of complexity concerning Jefferson's life and contributions, perhaps adding to his humanity as well as burnishing his genius. In downtown Charlottesville, you can find sixty titles about Jefferson in the regional library's central branch. They deal with his early days at Shadwell and Tuckahoe Plantations, his seminal role in the American Revolution, his penning of the Declaration of Independence, his fight for religious freedom, his years in Paris as minister to France, his presidency, the Louisiana Purchase, his domestic life at Monticello, his fathering children with Sally Hemings and much more.

But of all those books, not one has the word *beer* in the index. Known primarily as a connoisseur of wine, Jefferson was equally a beer geek. "Although George Washington was a well-known lover of beer and had his own brewing recipe, the title of America's first brewer fits Jefferson more accurately," wrote beer historian Gregg Smith in *Beer in America: The Early Years, 1587–1840.*

"[Jefferson] has a very special place in the story of beer in America," added Stanley Baron in his book *Brewed in America: A History of Beer and Ale in the United States.* Beer was a constant at Monticello, and the brewing process, with all its intricacies, attracted Jefferson's indefatigable curiosity. "He was…a champion of the brewing industry; being a gentleman farmer, he understood its important relationship with agriculture."

Look around Virginia now, and you find Jefferson's interests resonating with conspicuous vigor. The brewing industry is in a golden age, and farm breweries share Jefferson's passion for agriculture. Local craft breweries honor the past with brews such as 40 Mile IPA (a nod to Jack Jouett Jr.'s famous ride) and Monticello Reserve Ale (produced by Starr Hill Brewery in conjunction with researchers at Monticello).

Jefferson's influence is the most visible element of the brewing landscape. It is the purpose of the historical section of this book also to train a spotlight on two other prominent realities: the role of women in domestic brewing of the day and the contributions of enslaved people, both at Monticello and elsewhere in Virginia.

The scope of the latter has come as a surprise to me. Slaves grew hops and sold them back to owners. Not only that, but records show that a free black man in Charlottesville, Daniel Farley, also grew and sold hops. In addition, a Monticello slave, Peter Hemings, was trained by a professional English brewer and became proficient in the process, which included malting grains on the mountaintop. I'll venture out on a limb and say that it's quite possible Hemings was the first African American to be so thoroughly schooled in the brewing arts.

Two other pioneering efforts in the Greater Charlottesville region deserve note. It's not widely known that Charlie Papazian—author of a seminal homebrewing book and one of the iconic figures of America's craft brewing movement—got his first taste of homebrew while a student at the University of Virginia. And the region's Brew Ridge Trail, which connects a string of brewing pearls from the inner city to the outer reaches of Nelson County, has served as a model for other localities in devising marketing and tourist attractions focused on local breweries and cideries as destinations. The launch of the Shenandoah Beerwerks Trail—which extends those links across the Blue Ridge Mountains to Waynesboro, Staunton and Harrisonburg—is evidence of that success.

It's easy to understand the appeal. The rich history and natural splendor are matched by the excellence and diversity of beers here in the Piedmont. Devils Backbone, for example, has won numerous awards, not only for

individual beers but also for its overall operation (this was before the announcement in April 2016 that Anheuser-Busch InBev was acquiring Devils Backbone). At the Great American Beer Festival in Denver, it won back-to-back awards, for Small Brewpub and Small Brewing Company; when it outgrew that category, it won again for Mid-Size Brewing Company and Brew Team. Starr Hill, Champion, Three Notch'd—all have won national medals. Wild Wolf, James River and others have taken home awards as well, including from the annual Virginia Craft Brewers Cup competition.

One question I posed to nearly every person I interviewed in the beer and brewing community was this: "What would you say if someone asked you, 'What's the beer scene like in Charlottesville? What is its identity?'" Answers varied but centered on a common theme. I hope the pages of this book reveal that theme to you.

Chapter 1

A SURVEY TO REMEMBER

On Friday, September 19, 1746, a band of surveyors set out on a task that was both physically arduous and technically demanding. Their charge was to map a line connecting the headsprings of the Rappahannock and Potomac Rivers. The mission would carry them through thick forests and over craggy peaks. This was a wilderness where buffalo still roamed and deer and elk played, land that Monacans and other Native Americans had called home.

The task was serious, but a journal kept by one of the surveyors made it "obvious that they never passed up the opportunity to have a good drink," noted one historian. The journal makes no specific mention of beer, but "syder," rum, whiskey, punch and more eased their hardships.

A key member of the group was Colonel Peter Jefferson. He and his wife, Jane, were among the first settlers to establish a homestead in Virginia's Piedmont. Married in 1739, they planted their roots at Shadwell in what was soon to be Albemarle County. This was the birthplace of the son they named Thomas.

The couple came from contrasting backgrounds. Peter hailed from what is now eastern Henrico County, and although his father died in a reduced state, "for two or three generations the Jeffersons had been prominent members of the colonial gentry," wrote historian John Hammond Moore. Peter Jefferson assembled a handsome estate of some two thousand acres by the Rivanna River. The actual site for the Shadwell home was acquired from a friend in a facetious bargain for the price of "Henry Wetherburn's biggest bowl of

Peter Jefferson was among the officials who set rates for beer at ordinaries and taverns in 1745. *Photo of original in Albemarle County Courthouse.*

Arrack punch" in 1736 in a Williamsburg tavern, said Susan Kern in *The Jeffersons at Shadwell.* In the end, Jefferson paid fifty pounds for four hundred acres that included the homesite.

Jane Randolph, Peter's wife, was born in London of an English mother and Virginia father. She was no stranger to privilege, her family being one of the most distinguished and powerful in the colony. To survive and flourish in her new frontier home, however, Jane Jefferson had to fulfill the duties of a plantation mistress. And that meant knowing how to brew, bottle and store beer.

"The ideal planter's wife should be a capable learner, teacher and hostess," wrote Kern. "She should read and perform musically, master the diverse parts of the household devoted to foodways [including making beer], and she should do it with good humor. Jane Jefferson was this sort of planter's wife."

Beer played a central role in the life of the times. When settlers landed at Jamestown in 1607, they carried beer, a beverage filled with nutrients (barley being one of its basic ingredients). It also was a safeguard against drinking water, which was notoriously unhealthy in European cities and certainly suspect in Virginia's coastal bogs. Water had to be boiled—hence, purified—in order to brew beer.

Children and adults alike drank "small beer," a low-alcohol version that was the result of a technique common among brewers at the time. They

used the same grains for repeated mashings, much like using the same coffee grounds for multiple brews. Potency diminished with each run, from 8 to 10 percent alcohol by volume in the first run to 3 to 4 percent in the final one. So small beer was definitely a beverage suited more for quenching parched throats than quaffing for kick.

GOOD FOR WHAT AILS YOU

Today's mainstream beer consumers might have found the ales from Jane Jefferson's kitchen hard to swallow. Unlike the crisp, light pilsners that dominate the current market, colonial brews were dark and cloudy. "Despite its foul appearance, people knew beer was good for them; indeed, it was a major part of their diet and continued to be so throughout America's early years," said beer historian Gregg Smith.

Ales were good for what ails you. Got a runny nose? "Use Honey in Ale or Beer, with spices sweet," one 1708 almanac advised. Feeling down? Beer could ease melancholy. "Strong beer…would cure a 'weak brain,' while beer with catsvalerian roots would cure hysteria," noted historian Sarah Hand Meacham. Beer and other alcoholic beverages were even used as cleaning agents; hats and boots achieved a "brilliant jet lustre" when applied properly with beer or distilled wine.

The recipes of the day didn't always adhere to the traditional hops and barley. Persimmons, sassafras, pumpkins, cornstalks, spruce needles, molasses and a host of other ingredients found their way into brew kettles. Fermentation relied on propagating cultures of yeast from batch to batch; this mysterious organism was not isolated and understood until the mid-1800s.

By the time the Jeffersons began life at Shadwell—130 years after the landing at Jamestown—eastern Virginia had evolved from a smattering of settlers to a patchwork of planters. The Piedmont, however, remained wild and woolly. The only humans were likely to be Monacans or Manahoacs, part of a confederacy that had dominated the James River Valley. The Monacans had a fierce reputation and were bitter enemies of the Powhatans of eastern Virginia. Chiefly hunters, the Monacans raised some crops, including maize and squash. Little is known, however, of their daily activities, and practicing the brewing arts does not seem to be part of their heritage.

So it wasn't until the 1730s that beer made its appearance in the Charlottesville region. Albemarle County wasn't officially formed until

1744, and Peter Jefferson was among the leading figures of the community. A prominent landholder, an experienced surveyor and an officer in the local militia, Jefferson was among the first magistrates in the county. This august group met in 1745 at the county seat, then near Scottsville, and set rates for lodging, food and beverages at ordinaries (taverns) in the county.

Rates at Albemarle Ordinaries

Three rates were set for beer. A quart of Virginia cask beer would cost you seven and a half pence; the same amount of English bottled beer, one shilling (twelve pence); and a quart of English strong beer, eighteen pence. Compare that with a quart of Virginia cider, also a staple of the day, at six pence.

While the cost was established, quality was not. Some beer was undrinkable. "Such trash was never before brewed," one Virginian complained to his supplier in 1729. "I offered it to my negroes, and not one would drink it; the worst molasses rum that ever was brewed was cordial to it; I flung it every drop away."

Questionable quality didn't deter strong-willed men from strong drink, and that included the band of surveyors that Peter Jefferson headed in 1746. During one encampment, they "dined and regaled themselves with several black jacks of punch." (A black jack was an old-time leather beer mug coated with tar.)

Such drink, while fuel for merriment, also served as fortification for tests of strength and endurance. The group was forty strong and included axe men to clear the way for the surveyors to run a straight line using only compass and chain. This line made no allowance for terrain; it pointed over streams, through dense swamps and up slopes thick with boulders and trees. Jefferson, renowned for his strength, provided a formidable presence, but even he became exhausted and sick. Horses nearly died from thirst on one hot September day.

A critical point stands out in the notes of Thomas Lewis, who kept a journal of their work. It came on October 3, a Friday, some thirty miles into their journey and facing a jumble of rocks in the mountains lining the western edge of the Shenandoah Valley. Lewis wrote (spelling has been modernized), "This day several of the horses had like to been killed, tumbling over rocks and precipices, and ourselves often in utmost danger. This terrible place we called Purgatory."

Peter Jefferson's surveying party encountered extreme difficulty crossing the ridge then known as Devil's Back Bone. *Library of Congress.*

The mountain they climbed, a purgatory to them, had another name, one that connects the 1746 survey to today's burgeoning beer culture and Virginia's most decorated and most prolific homegrown brewery. Modern maps label the spot as Great North Mountain. A 1755 map following the survey gives the ridge a different name: Devil's Back Bone.

THE WORK OF WOMEN AND SLAVES

Thomas Jefferson was surrounded by beer most of his life. At Shadwell, at the College of William and Mary, at Monticello, during his term as governor of Virginia, as president of the United States and, particularly, in his later years as the grand patriarch atop his little mountain, he always had beer at hand. The only exception was his time as minister to France, when his beloved wine trumped all other beverages.

Alcoholic beverages in general were in abundance at Shadwell, where Jefferson spent his earliest years. Wine, rum, whiskey, cider, beer—all were present, but only cider and beer were made on the premises.

Young Jefferson would presumably have drunk small beer, a weak everyday beverage consumed by all ages. And he surely was aware of his mother's role in keeping the plantation supplied with beer, cider and other beverages. It was her job to "brew, bottle and store beer—or to oversee the daughters and slaves who did it under her direction," wrote Susan Kern in *The Jeffersons at Shadwell.*

Little credit has gone to the ones who actually did the hands-on brewing: the slaves in the kitchen. Brewing was a skill much valued, as shown in this ad in a Virginia newspaper: "For sale: A valuable young Negro woman, very well qualified for all sorts of Housework, as Washing, Ironing, Sewing, Brewing, Baking, &c."

An experienced brewer in the kitchen would have been an invaluable help for Jane Jefferson. It's unlikely that she learned to produce beer from her mother, whose circumstances living in wealth in London meant that both

Shadwell was like many Virginia households—brewing beer was a domestic art managed by the plantation mistress, in this case Jane Jefferson. *Photo by Lee Graves.*

slaves and the necessity for domestic brewing were absent, and once the family moved to Virginia, wealth continued to insulate the Randolphs from many everyday chores.

Instead, Jane more likely relied on brewing texts and cookbooks. Indeed, the Shadwell library included an octavo titled *The London and Country Brewer*. First published in 1736, the book was written by brewer William Ellis after he spent more than four years touring parts of England. Ellis outlined how to brew malt liquors and explained how to preserve beer in casks and bottles.

Some of Ellis's tips are quite practical and would have been easily applied on the plantation. For example, the book offers four ways to "know good from bad Malts." One of those is "[b]y Water; [it] is to take a Glass near full, and put in some Malt; and if it swims, it is right, but if any sinks to the bottom, then it is not true Malt, but steely and retains somewhat of its Barley nature; yet I must own this is not an infallible rule."

A section of the book that must have spoken directly to Jane Jefferson is titled, "The Country or Private Way of Brewing." It addresses small-batch brewing under rural conditions and pays particular attention to making

small beer: "I will suppose a private Family to Brew five bushels of Malt, whose Copper holds brim-full thirty six Gallons or a Barrel: On this water we put half a Peck of Bran or Malt when it is something hot…and when it begins to Boil, if the water is foul, skim off the Bran or Malt and give it to the Hogs." (Two asides: The current measure of a barrel in the United States is equal to thirty-one gallons, not thirty-six. Also, many brewers today still offer their spent grains to farmers as feed for livestock.)

When it comes to hopping, Ellis recommends putting half a pound of hops in a canvas or loose-woven cloth and boiling for half an hour, "when they must be taken out, and as many fresh ones put in their room as is judged proper to boil half an Hour more, if for Ale: But if for Beer, half a Pound of fresh ones should be put in at every half Hour's end, and Boil an Hour and a half briskly."

Here is an important distinction: ale versus beer. Up until the sixteenth century, English brewers made what was called "ale" without hops, although the cultivation of hops was well established on the island. Those who adulterated this ale with hops or spices were subject to fines. "Eventually, not even fines were sufficient to keep English ale brewers from experimenting with the use of hops in their ales," noted *The Oxford Companion to Beer.* Hops not only provided bitterness to balance the sweetness of malt but also served as a preservative.

HOPPY BREWS WERE STANDARD

Even Ellis comes to hops' defense: "This Vegetable has suffered its degradation, and raised its Reputation on the most of any other. It formerly being thought an unwholesome Ingredient, and till of late a great breeder of the Stone in the Bladder, but now that salacious Notion is obviated by [those]…who have proved that Malt Drink much tinctured by the Hop, is less prone to do that mischief, than Ale that has fewer boiled in it."

While we don't know if Jane Jefferson followed Ellis's guidance precisely, later evidence suggests that hoppy brews were the standard. Thomas Jefferson, his wife and his daughter all recorded numerous purchases of hops, particularly from slaves, and although Jefferson said that he used no recipes for making beer at Monticello, his reference to the amounts of hops used in brewing indicates their generous application. And unlike the British tradition of using barley, which was dear in colonial Virginia, domestic

Left: Thomas Jefferson's time at the College of William and Mary is marked in many ways, including this likeness on Duke of Gloucester Street. *Photo by Lee Graves.*

Below: Jefferson's hand in writing the Declaration of Independence is central to his legacy. *Photo by Lee Graves.*

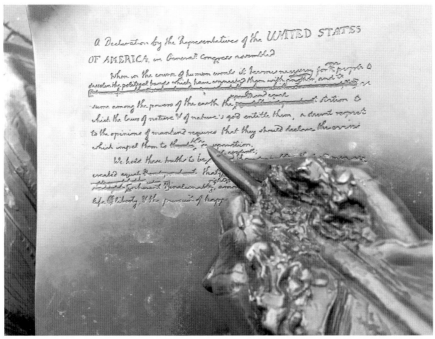

brewers often used wheat and molasses to produce the fermentable sugars that eventually yielded alcohol.

In addition to *The London and Country Brewer*, Jane Jefferson would have had cookbooks at hand, and they were common resources for making alcoholic beverages. "The women's careful passing of the cookbook through the female side of the family suggests that alcoholic beverage recipes were valued property," said historian Sarah Hand Meacham. A later cookbook written by Mary Randolph, a member of Thomas Jefferson's extended family, provides an example. *The Virginia House-Wife*, published in 1824 and one of the best-known cookbooks of its time, included recipes for mead, ginger beer, spruce beer and molasses beer (the beers were unhopped).

The importance of the malt beverage was illustrated when Peter Jefferson prepared for the family's return to Shadwell. They had moved east to Tuckahoe, home of Jane's cousin William Randolph, to live from 1745 to 1752; in the early 1750s, Peter Jefferson made extensive repairs and improvements at Shadwell that included land for grain cultivation and a gristmill, as well as renewed attention to brewing.

How did beer stack up against the other beverages in the Shadwell household? An inventory of the cellar's contents taken by Thomas Jefferson in September 1769—twelve years after his father's death and two years after completing his law studies in Williamsburg—revealed more than 250 bottles of alcohol, including 85 bottles of rum, 15 bottles of Madeira wine, 54 bottles of cider, 4 bottles of Lisbon wine and small beer (in unspecified quantity). There were several empty bottles, and Kern speculated that Jane Jefferson spent the next month brewing beer and bottling spirits, for on October 2, Thomas counted "434 bottles of alcohol, including 66 bottles of small beer, and new stocks of rum and Lisbon wine, in addition to the Madeira and cider there."

Brew House at William and Mary

Speaking of the College of William and Mary, archaeological evidence points to a brew house located next to the iconic Wren Building on the college's historic campus while Thomas Jefferson was a student there. The institution's rules during the eighteenth century specified that "no liquors shall be furnished or used at table except beer, cider, toddy, or spirits and water." It's likely that Jefferson was drinking beer brewed on campus during

his days as a student and while reading for the law under the mentorship of George Wythe. Jefferson also was a frequent visitor to the Governor's Palace, just a brisk walk down Duke of Gloucester Street, where beer was brewed on-site to slake the thirst of guests.

One note about the brewery at William and Mary: Documents discovered as part of the Lemon Project, which is examining the college's relationship with slavery and race, reveal that the college made several payments to slaves for hops, including a sum paid in 1755 to the "Nottoway Negroes." "[The phrasing] shows the college was paying its own slaves for something they were producing—beyond tobacco for the college to market," Terry Meyers, a W&M English professor and past co-director of the project, said in a 2014 alumni magazine article. And at the Governor's Palace, one account shows the purchase of forty pounds of hops from Carter's Grove, the Burwell family plantation nearby. "I would be willing to bet that they were grown by slaves," said Frank Clark, master of historic foodways at Colonial Williamsburg.

That thread continues as we follow Thomas Jefferson on his ascendancy, both figuratively and literally. As he rose in prominence among the core of colonial leaders, Jefferson also climbed to his new home in Albemarle County in 1772 with his bride, Martha Wayles Skelton. The full structure of

This document records payments for hops made in 1755 to the "Nottoway Negroes," ostensibly for brewing at the College of William and Mary. *Courtesy of the Lemon Project, College of William and Mary.*

Monticello was yet to take shape, but Martha quickly assumed management of domestic affairs, including brewing beer. They arrived in January of that year, and the following month, on the first page of her account book, Martha noted, "A cask of small beer brewed. 15 gallon cask."

She oversaw the brewing of nine more casks of beer in her first year at Monticello, and records show her purchasing hops frequently. But where did those hops come from? Even before settling at Monticello, Thomas Jefferson was buying hops from slaves. "Pd. Colo. Lewis's Ned for 2 lb hops," he wrote in his Memorandum Book in March 1771. Martha likewise paid Monticello's enslaved workers for hops, including one famous purchase of hops in 1774 for "an old shirt."

The business of revolution called Thomas away from Monticello to Philadelphia, to Williamsburg and then to Richmond when the capital was moved there in 1780. Jefferson's accounts reflect numerous beer purchases, and the large amounts of some payments suggest his duties as host while governor.

The war for independence was a distant rumble in Central Virginia until January 1781, when General Benedict Arnold marched on Richmond. As governor, Jefferson directed the removal of public records to Westham, where a foundry (and brewery) existed, before fleeing the city to points west. What follows—one of the exciting moments in Albemarle County lore—gives us a chance to open the door to another area of the region's beverage history.

TAVERN LIFE—AND A RIDE TO REMEMBER

L et's call this the tale of two taverns.

One was the Swan. It was built by John Jouett shortly before the Revolutionary War on the east side of Charlottesville's public square, a spot known in those days as "the Grass Lot." Jouett was a Patriot of the first order. He had signed the Albemarle Declaration of Independence, which disclaimed loyalty to King George III. Among the 202 citizens of Albemarle who signed the document was his son, John Jr. ("Jack" to all who knew him). Jack's three brothers served in the military, and his father supplied meat to the troops.

The Swan Tavern was more than just a watering hole. Sure, ale and beer flowed, as did cider, rum, whiskey and all the creative concoctions of the day—toddy, flip, sangre, sower punch, hot spiced cider, wassail and more. But taverns and ordinaries were gathering places for a range of activities, from court sessions to socializing, from playing cards to discussing politics and war.

Both of those latter subjects dominated the talk at the Swan in the spring of 1781. British forces approaching Richmond flushed the state's legislators and its governor, Thomas Jefferson, from the capital to Albemarle County. In fact, a few of Virginia's finest—including Patrick Henry (a noted beer lover), Benjamin Harrison, Richard Henry Lee and Thomas Nelson Jr.—were staying at the Swan as they regrouped. Jefferson was just up the mountain at Monticello.

The second of our taverns is the Cuckoo, about forty miles away in Louisa County. At roughly 9:30 p.m. on June 3, 1781, Jack Jouett was there,

Above: Jack Jouett Jr.'s ride in 1781 is part of the local lore in Louisa and Albemarle Counties. *Photo by Lee Graves.*

Left: Three Notch'd Brewing Company's 40 Mile IPA pays tribute to Jack Jouett Jr.'s ride to warn state officials. *Courtesy of Three Notch'd Brewing Company.*

quaffing a beverage of choice. He was a conspicuous presence—about six-foot-four, two hundred pounds, twenty-six years old and, by many accounts, dashingly handsome. He wore a distinctive military costume, a scarlet coat with a plumed hat.

On this moonlit night, Jouett observed about 250 British soldiers—180 dragoons and 70 cavalry—pause near the Cuckoo; the troop was led by Lieutenant Colonel Banastre Tarleton, nicknamed "Bloody Tarleton" by his foes. Jouett quickly guessed their mission: to capture Jefferson and the other officials.

What happened next is memorialized today in one of Charlottesville's craft beers. Three Notch'd Brewing Company's 40 Mile IPA is the company's flagship beer, and its name is a nod to the distance that Jack Jouett covered after climbing onto his horse and racing those dozen leagues—through bramble thickets and across the Rivanna River—to warn Jefferson and the group at the Swan, "The British are coming! The British are coming!" (Jouett is indeed known as the "Paul Revere of the South.")

Not Models of Moderation

The tale of taverns in the region stretches far beyond these two. The connection between the craft brewery tasting rooms of today and the inns and ordinaries of yesteryear is not much of a stretch, although the former are better models of moderation than the Swan, Cuckoo and others. "People then just drank so much alcohol. There was a lot of peer pressure to hold alcohol," said Cynthia Marie Conte, coauthor of *A Taste of the 18th Century* and curator of Michie Tavern.

Conte and I stood in the "taproom" at Michie Tavern, where most of that drinking would have taken place. Although the tavern has been relocated from its original site—it's now a thriving tourist attraction under the brow of Monticello—the smell and the creak of wood and the careful attention to historic detail made it easy to imagine the clank of ale-filled tankards and the buzz of revolutionary rhetoric filling the hall.

The Michie was not among the first taverns in the region. In the years immediately after Albemarle County became an official entity in 1744, licenses were granted for nearly a dozen ordinaries, stretching from the Rockfish Valley and Afton Mountain to the county courthouse. Remember

TAP BAR ROOM

This room bustled with activity and on most evenings the air would be thick with the scent of smoked venison, tobacco and ales. Travelers as well as local gentlemen would gather in this room to socialize while they drank, smoked, played games and dined. Tavern tables, gaming and writing tables surrounded by a variety of chairs filled this area. Bottles of different sizes and colors, drinking vessels of pottery, pewter or glass, playing cards, paper and quills, pipes and tobacco attest to the room's many functions.

In this room as well as throughout the rest of the tavern, furnishings provided flexibility to accommodate many guests. Flexibility was vital to a tavern's survival since the innkeeper had to adapt to the number and needs of diverse patrons. The focal point of this room is the Tap Bar where drinks were dispensed from inside as well as outside on the porch.

"The accommodations at taverns, by which they call inns, are very indifferent. The traveller is shown, on arrival, into a room which is common to every person in the house."
Issac Weld of Philadelphia, 1790

Cider, ale, punch, rum, whiskey—all were part of the fare at ordinaries such as Michie Tavern, and alcohol was consumed liberally by patrons. *Photo by Lee Graves.*

that Peter Jefferson, Thomas's father, was among those who set rates for the fare, including beer.

In addition to being consumed on its own merits, beer was a common ingredient in the punches of the day. Flip, for example, consisted of strong beer with rum and sugar or molasses added (eggs, cream and even dried pumpkin were also common ingredients). A hot poker was inserted into the mix to heat it and create a frothy head. Sangre was a mixture of wine or beer sweetened with sugar and flavored with nutmeg.

Hard cider also was popular, but the hard-drinking colonials regarded cider and beer as healthful beverages of temperance compared with rum and whiskey, which were consumed so liberally that Henry, Jefferson and other leaders were concerned about liquor's ill effects on society. Drinking to excess was so common, and often expected, "that a man could not have a more sociable quality of endearment than to be able to pour down seas of liquor and remain unconquered while others sunk under the table"—or so a traveling physician was told in New York in 1744.

What was the average ordinary in Albemarle County like? Well, generalizations are often misleading, but a colorful account survives from Major Thomas Anbury, a British officer held captive during

the Revolutionary War (Barracks Road gets its name from the area of Charlottesville where numerous prisoners were quartered during the Revolution).

"Entertainment Is Very Poor"

"All taverns and public houses in Virginia are called Ordinaries, and 'faith, not improperly in general,'" Major Anburey is quoted in Edgar Woods's famous 1901 history of Albemarle County. "They consist of a little house placed in a solitary situation in the middle of the woods…and the entertainment you meet with is very poor indeed; you are seldom able to procure any other fare than eggs and bacon with Indian hoe cake, and at many of them not even that. The only liquors are peach brandy and whiskey. They are not remiss however in making pretty exorbitant charges."

Anburey noted that the town itself had only one tavern, presumably the Swan. That gathering place was a fixture of Charlottesville until 1832, when it was "pulled down," according to historian James Alexander. At the moment of its demise, a ball was underway at the Eagle Hotel nearby. "The noise of the crash startled the belles and beaux, and caused them to think it was the rumbling of an earthquake—it was only the exit of the Swan, singing its dying notes."

The Eagle Hotel began as the Eagle Tavern, built shortly after the Revolutionary War. For two years after the Civil War, it served as headquarters for occupying Federal forces. Some of its timbers allegedly were used to build the venerable Monticello Hotel. Other spots around the area in those years were the Stone Tavern, also on Courthouse Square (scene of two memorable celebrations, one in 1806 to toast Meriwether Lewis's return from western explorations and the other in 1824 to honor the visiting Marquis de Lafayette); Terrell's Tavern at the corner of Fifth and Market Streets; the Hardindale Inn, built in 1805 one mile west of Ivy; the Sign of the Green Teapot, a bit farther west; the Pinch-'em-Slyly! to the north (what a great name); the Rising Sun and Woods' Ordinary, both on Three Notched Road; Shepherd's Inn, a stagecoach stop between Richmond and Charlottesville; Michie Tavern northwest of town; and a place appropriately named Mountain Top Inn, in Rockfish Gap on the shoulder of Afton Mountain.

Mountain Top Inn has a special place in local history. In August 1818, Thomas Jefferson, James Madison, Joseph Cabell and eighteen other

Michie Tavern was moved from its original site on Buck Mountain Road to the foot of Carter's Mountain in the 1920s. *Photo by Lee Graves.*

dignitaries met there in a low, whitewashed room furnished with a "deal" dining table and split-bottom chairs. The men were members of the Rockfish Gap Commission, appointed by the governor to recommend a location for a state university. Jefferson had recently succeeded in creating Central College as an upgrade of the Albemarle Academy. It took a minimum of arm-twisting—accompanied, no doubt, by pints of beer and cider—for Jefferson to persuade the commissioners to recommend Central College in Charlottesville as the site for this state institution. Hence the University of Virginia was born.

Meanwhile, Michie Tavern was making its mark on Buck Mountain Road, between Free Union and Earlysville. Built in 1777 by William Michie, a corporal in the Continental army and another signer of the Albemarle Declaration of Independence, the ordinary served the same role as other taverns: a place to debate the issues of the day. "One can almost imagine the heated political discussions that took place over a tankard of ale or spiced rum," Conte wrote.

"No Beer in the Kitchen"

A magistrate and sheriff, Michie was a man of rules, and two of those for the tavern staff give a chuckle. To prevent employees from eating customers' food, servers were required to sing as they brought the food from kitchen to table. In a similar vein, to curb illicit imbibing, another rule plainly stated, "No Beer in the Kitchen."

The tavern operated until the mid-1800s and then served as a private residence. Concern for the deterioration of this landmark spurred Josephine Henderson, a local businesswoman, to lay plans in 1927 to relocate the Michie to the foot of Carter's Mountain, where thousands of tourists passed each year on their way to Monticello. The effort called for each piece of the tavern to be numbered, moved seventeen miles by horse-drawn wagon or truck and reassembled. Since 1928, it has operated as a museum with regular tours and a restaurant specializing in authentic eighteenth-century fare. It is on Virginia's list of historic landmarks.

The site also includes a general store housed in the eighteenth-century Meadow Run Grist Mill. And there, just as Three Notch'd Brewing

Virginia beers are part of the appeal in the eighteenth-century Meadow Run Grist Mill by Michie Tavern. *Photo by Lee Graves.*

Company's 40 Mile IPA connects the present with the past, craft beers from around the state and beyond are displayed on shelves that hark back to colonial times. If you time it right, you can partake in wine, cider and beer tastings on selected weekends.

There are two brews in particular you might look for. Thomas Jefferson's Tavern Ale, brewed by Yards Brewing Company in Philadelphia, uses honey, rye and wheat—"just like the beer Jefferson made at Monticello," the brewery notes on its website. Flaked maize also goes into the beer, configured as a strong golden ale at about 8 percent alcohol by volume. Another beer to keep an eye out for is Monticello Reserve Ale, created by Monticello curators in conjunction with Starr Hill Brewery in Crozet. The telling of that ale's tale comes in a later chapter.

Before moving on, let's take a minute to complete the Jack Jouett story. As mentioned earlier, he favored eccentric dress—a military costume of scarlet coat and plumed hat. After alerting Jefferson to the danger at Monticello, Jouett rushed to the Swan to warn the legislators, who decided to skedaddle to Staunton. One of the Swan's patrons was General Edward Stevens, who had been wounded in battle and was unable to ride quickly. Jouett stayed with Stevens, who was dressed shabbily. When the British appeared, they ignored Stevens because of his shoddy appearance and pursued Jouett, thinking he was an officer. Jouett escaped, and his bravery was honored by Virginia's General Assembly, which awarded him a sword and pair of pistols. Jouett ended his days in 1822 in Bath County, Kentucky, where he was buried in an unmarked grave.

Chapter 4

BREWING AT MONTICELLO

Tucked away in the southern wing of Monticello's dependencies is a room that gets little more than passing interest from many visitors. It is the beer cellar. The display of jugs and bottles, corks and barrels, placards and drawings illustrates the importance of beer and brewing on the mountaintop. On a deeper level, the room also represents a unique juncture of the plantation's mistress and master and a slave, their lives joined by blood as much as beer.

As previously mentioned, Martha Wayles Skelton Jefferson was an avid brewer. She recorded sixteen brew dates in her first year at Monticello. And although her husband was known to prefer wine and cider, "as a young husband married to a bride who was proud of her beer-making, he undoubtedly consumed a lot of small beer," wrote Jack McLaughlin in *Jefferson and Monticello: The Biography of a Builder.*

Jefferson wasn't the only beneficiary of Martha's brewing. From all indications, Martha's beers were well hopped, and the gardens of slaves at Monticello served as a source for many of those hops. Although the Jeffersons purchased all kinds of produce, fish, game and other consumables from their slaves, "hops was among the most frequently purchased product from the slave community by Martha," wrote author Peter Hatch, former director of gardens and grounds at Monticello.

She also bought hops from neighbors' slaves. She bought hops from slaves while in Williamsburg. And either Martha or her husband bought hops en route to Monticello. These purchases reflect a broader exchange between

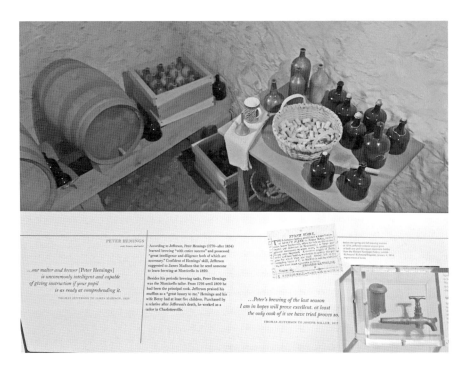

Peter Hemings's role as brewer at Monticello is on display in the beer cellar. *Photo by Lee Graves.*

slaves and brewers in the colonial community. Even George Washington's accounts show a payment in 1798 to one Boatswain, a ditcher at the Mansion House farm, for six pounds of hops.

Hops are a native species in Virginia, and some of these hops could have been growing wild. The presumption, though, is that most were cultivated. Growing this woody perennial is physically demanding and time-consuming. Considerable attention must be given to building a trellis or equivalent structure, such as poles leaned together in tepee fashion, for the bines to climb; they can reach up to twenty-five feet in a season. Weeding and pruning are critical and nearly constant during the growing season, which is from March to August. Modern hops farmers also have found that Virginia's humid climate invites fungi—downy and powdery mildew in particular. Harvesting the hops by hand, while not as punishing as picking cotton, is slow, tedious and tiresome work (modern growers estimate that it takes one hour to pick a pound of hops).

The slaves cultivating these hops—Goliah, Bagwell, Phil and others at Monticello—would have been field hands. They labored from dawn to

Martha Wayles Skelton Jefferson, Thomas's wife, recorded sixteen brew dates in her first year at Monticello. *Library of Congress.*

dusk six days a week (Sundays usually were free). Evidence suggests that abundant slave gardens existed at Monticello over the years, and the volume of hops produced implies that they were an established crop. Given the limited daylight available to tend these gardens, the attention to hops gains additional emphasis. "Hop growing is serious horticulture," said Hatch. Just how serious? The most eye-opening exchange occurred in 1818, when Thomas Jefferson paid Bagwell Granger, a notable figure in Monticello's slave community, the amount of twenty dollars for sixty pounds of hops. Let's look closer at these numbers.

Lucia Stanton, author of *Free Some Day: The African-American Families of Monticello* and coeditor of Thomas Jefferson's *Memorandum Books*, helped put the dollars in perspective: multiply by forty to get the equivalent modern sum. So $20 to Bagwell would have been the approximate equivalent of $800 today. "That seems like a lot," she said. "Still, it's a fraction of what it would have cost to buy a family member's freedom, when you think of it in that context."

Hops were grown during Thomas Jefferson's time and continue to be a part of the historic garden at Monticello. *Photo by Lee Graves.*

David Goode, a co-founder of Piedmont Hops and a prominent member of the Old Dominion Hops Cooperative, put into perspective the weight of the hops—whether they had been dried or were freshly picked (called "wet" hops). "If they were wet and not dried, it would take sixty plants, maybe more. I'm not sure what the yields were like then. However, if they were dried, it would be five times that amount—three hundred plants."

Beyond the efforts of these African Americans, Jefferson in 1794 began planting hops in his own garden; they grew in the submural beds below the garden wall in a plot as long as one hundred feet.

We have no way of knowing the potency of these hops, in terms of bitterness, aroma or flavor—no means existed to measure alpha and beta acids, essential oils and cohumulone levels. Or what variety—an English breed, such as Fuggles or East Kent Goldings, perhaps? But an experienced, professional brewer would be able to roll the cones between his fingers, feel the sticky oil, take a whiff of the fragrance and make a reasonable guess as to their proper use in a beer recipe.

Fortunately, just such a brewer would happen upon the Monticello scene, purely by accident, in 1813. Thomas Jefferson, however, would be a changed man by then.

The Toll of Martha's Death

Nothing altered Jefferson's personal life as much as the death of Martha in 1782. "Although [her death] could not have been unexpected, Jefferson was not prepared for the finality of their separation," wrote historian Annette Gordon-Reed. "He gave himself over to a grief that was so enormous that it frightened those around him. He stayed in his room for weeks," walking incessantly, to the point of exhaustion.

A spirited woman with a ready laugh, Martha Wayles Skelton Jefferson was known for her beauty—she had a brilliant complexion, hazel eyes and auburn hair. She served as a source of wit, charm and music on the mountaintop. She was small in stature and not physically strong, however, so her never-ending duties as plantation mistress, combined with those of being a wife, hostess and mother during a tumultuous time in American history (and while Monticello was in a state of constant construction), took a tremendous toll.

Her final hours came at the end of a long decline from giving birth to the couple's last child, Lucy Elizabeth. According to the enslaved women who served Martha, as she lay dying she made Jefferson pledge never to remarry. In the room to hear Jefferson make that promise, one he kept, were members of the Hemings family. They held a special place at Monticello, for Martha's father, John Wayles, fathered half a dozen of the Hemingses. They were her kin, half sisters and half brothers; they also were property owned by the Jeffersons.

Sally Hemings has been the focus of the most attention by latter-day historians. But another Hemings, her brother Peter, would play an important

Above: Thomas Jefferson designed this Palladian-style brew house at Monticello, but no evidence of its construction has been found. *Collection of the Massachusetts Historical Society.*

Left: A detailed image of the proposed brew house. *Collection of the Massachusetts Historical Society.*

role in several capacities —as a tailor, as a chef and as a brewer. In a sense, he continued what Martha had started at Monticello.

Martha's interests also guided her husband's hand in drawing dependencies that neither would live to see realized. "The kitchen under the south pavilion was to be converted to a brewing room with a circular masonry firebox to hold a large brewing kettle," McLaughlin wrote. "There is little doubt that Martha Jefferson, beer-maker, had a voice on its design and location."

After Martha's death, Jefferson's devotion to public service took him to Paris as minister to France and then to the White House, where he served as the nation's third president from 1801 to 1809. The swirl of political life in Washington left him yearning for the rural life of a gentleman farmer, so he retired to his beloved Albemarle mountain home.

War loomed, however, and it would create circumstances Jefferson could not have foreseen. One of his great concerns was the level of alcoholism among his countrymen, and beer's role as a beverage of temperance spurred him to advocate for and explore the brewing of beer. "I wish to see this beverage become common instead of the whiskey which kills one third of our citizens and ruins their families," he wrote.

To that end, he enlisted the help of Captain Joseph Miller, who had been a professional brewer in London. Miller had left England to claim family estates in Norfolk, Virginia, but a series of misfortunes, including the outbreak of the War of 1812 and a shipwreck, left him stranded in Albemarle County. Although born in America, he was considered an alien in enemy territory.

Jefferson intervened, taking him under his wing and his roof. "I have great esteem for [Captain Miller] as an honest and useful man. He is about to settle in our country, and to establish a brewery in which art I think him as skilful a man as has ever come to America," Jefferson wrote.

Correspondence with an Albemarle County neighbor, George Gilmer of Pen Park, indicates that something more than domestic brewing was on Jefferson's mind before Miller appeared. Writing from Philadelphia in 1793, Jefferson lamented being delayed in Philadelphia, giving Gilmer a head start "in your manufactures of porter and macaroni, in which however I shall certainly attempt to rival you."

With Miller's arrival, the wheels started turning to set up a full-scale brewing operation at Monticello. Jefferson wrote to another neighbor, Captain W.D. Meriwether, asking for the return of essential brewing books: *The London and Country Brewer* (the same work that guided Jefferson's mother) and Michael Combrune's *The Theory and Practice of Brewing*. The latter explained advances

in science and technology, such as using a thermometer in the malting and brewing processes.

Meriwether had supplied malt to Jefferson at least twice in the spring of 1812. That year's accounts also show a purchase of hops for $1.33 from one of Charlottesville's interesting individuals—a free black man named Daniel Farley (more about him in a bit).

"A BREWER FOR FAMILY USE"

On September 17, 1813, Miller began his role as the beer mentor of Monticello, with Peter Hemings as his student. Although Jefferson would later describe himself strictly as "a brewer for family use," Miller's professional background would enable Hemings to learn sophisticated techniques. Not much is known of Hemings; no physical description exists, although members of the Hemings family were well known for being light-skinned. Peter was a skilled tailor and had been trained by his brother, James, in the nuances of French cuisine (James had accompanied Jefferson to Paris to study cooking).

Peter Hemings apparently was a quick study in brewing as well as his other skills. Jefferson described him as possessing "great intelligence and diligence both of which are necessary." Improvisation also was required because barley, beer's grain of choice, was not grown at the plantation and was expensive to import.

So, in 1814, they began to malt wheat (corn would follow after Miller's departure). Malting is the process by which grain is spread on a floor and then watered and heated to induce germination; the resulting sprouts are gathered for the first step in actual brewing, called "mashing." That's where the malt is mixed with hot water to form a porridge-like mix rich in maltose and other fermentable sugars (malt basically gives beer its sweetness). The mush is cleared by filtering through the spent grain and then it is boiled with hops, which provide balancing bitterness. Next, the "wort," as it is called, is pitched with yeast and allowed to ferment. Yeast wasn't fully understood in colonial times, so brewers would add beer that already contained yeast to induce fermentation. The beer finally was stored in kegs and allowed to rest for at least two weeks in a cool spot.

Although beer and cider were considered table beverages at Monticello—meaning they did not have the status or alcohol content of wine—Jefferson did

not tolerate insipid beer. He specified a bushel of malt for every eight to ten gallons of "strong beer, such as will keep for years." And three-quarters of a pound of hops was used for every bushel of wheat. Jefferson criticized "public breweries" that stretched the grain bill to fifteen gallons for every bushel of malt; that, Jefferson said, "makes their liquor meager and often vapid."

Monticello's brewing schedule was seasonal. In the fall, three sixty-gallon casks of ale were brewed in succession. Similar brewing followed in the

Thomas Jefferson's letter to Captain Joseph Miller of June 1815 describes brewing, including the use of corn, at Monticello. *Library of Congress, Manuscript Division.*

spring. For production on that scale, Monticello needed a brew house, built in time for brewing in the fall of 1814. An undated drawing shows Jefferson's plans for a Palladian-style brew house, but it is unknown if it was ever built. The location of the brew house that was used has not been determined.

Brewing in that volume also demanded plenty of kegs, bottles and corks, a constant concern for Jefferson. In an 1816 letter, Jefferson asked Bernard Peyton to procure four gross of bottles, "the strong kind preferred and 12 gross of corks, the best, as bad ones is throwing away our liquor." He again emphasized in an 1819 letter to Miller the importance of high-quality corks to bottle his beer and cider. "It is so provoking to lose good liquor by bad corks." Always the geek, he even advised about proper storage: "Let the beer be put into the cellar immediately, for fear of its freezing, setting the proper head of the barrels uppermost, that the bottles in them may stand with the corks up."

Peter Hemings was able to experiment with malting corn, which, when combined with wheat in the brewing, tended to give the beer a sweet, buttery flavor. Jefferson's interest in using corn led him to seek another beer book, *The American Brewer* by Joseph Coppinger.

Contact with Coppinger provided an interesting tangent in Jefferson's beer experience. Before the outbreak of the War of 1812, Coppinger had written to James Madison, president at the time, about the potential for establishing a national brewery in Washington, D.C. Coppinger waxed eloquent on two particular points: "It has in my view the greatest importance as it would unquestionably tend to improve the quality of Malt liquors in every point of the Union and to serve to counteract the baneful influence of ardent spirits on the health and Morals of our fellow Citizens." In a second letter, he argued in favor of beer as a healthful beverage.

"THE BUSINESS OF BREWING"

Coppinger outlined a plan to raise $20,000 by selling subscriptions of $500 and $1,000. England, he noted, received substantial revenue through breweries. And he would be glad to serve as brewer, having "followed the brewing trade nearly twenty years [and] in that time built two breweries on my own Acct."

Madison forwarded the letters to Jefferson; they were friends, and Jefferson was far more acquainted with brewing practices. There is no evidence,

however, that either man replied to Coppinger at that time. It wasn't until after the war that the issue rose again, when Coppinger reasserted his proposal directly to Jefferson in April 1815 (he also promoted his beer book, which Jefferson had been trying to acquire).

Jefferson replied before the month was out. Changing the public's taste away from ardent spirits in favor of malt beverages would be difficult, he wrote. Moreover, "the business of brewing is now so much introduced in every state, that it appears to me to need no other encouragement than to increase the number of customers." He expressed more excitement about Coppinger's book and learning about corn in brewing. "The brewers on James river used Indian corn almost exclusively of all other. In my family brewing I have used wheat also as we do not raise barley." The correspondence foundered. Coppinger didn't reply until September, and although he attached a prospectus of his book, there's no record that Jefferson ever received a copy (of course, that doesn't mean he didn't).

Still, brewing was going apace at Monticello. "We brew 100 [gallons] of ale in the fall & 300 [gallons] in the spring," Jefferson wrote in 1821 to James Barbour, a former governor of Virginia and a U.S. senator at the time. Peter Hemings's skills also were noted in Jefferson's letters: "Peter's brewing of the last season I am in hopes will prove excellent. At least the only cask of it we have tried proved so."

Jefferson's correspondence with Barbour shed light on another facet of Monticello's brewing. Barbour recalled drinking some ale at Monticello, expressed his own interest in brewing and sought a copy of Jefferson's recipe. Jefferson replied that he not only had no recipe for brewing, but "I much doubt if the operations of malting & brewing could be successfully performed from a [recipe]." The letter gave a tip of the hat to Miller, who had since departed Monticello, and invited Barbour to send a "capable servant" to attend the fall brewing to get an idea of the process. He also recommended Combrune's book, a sign of its high status in Jefferson's library.

Uncertain Fate for Slaves

James Madison also apparently inquired about brewing, for Jefferson wrote to him in 1820 about the process, including a recommendation to build a malting house "by digging into the steep side of a hill, so as to need a roof only, and you will want a hair cloth also of the size of your loft to lay the

grain in." Jefferson invited Madison to send a man to learn about brewing from Peter Hemings. "I will give you notice in the fall when we are able to commence malting and our malter and brewer is uncommonly intelligent and capable of giving instruction if your pupil is as ready at comprehending it."

We can assume that brewing continued at Monticello until Jefferson's death in 1826. His passing, though, left an uncertain fate for Peter Hemings and others. A lifetime of debt saddled Jefferson's estate, and the heirs decided to hold an auction of property, including slaves. Daniel Farley was one of those at the auction. He lived on Main Street just outside the town's eastern limits, and his home was notorious for being a center for entertainment. He was a talented fiddler and a "frequent transgressor" of gambling laws; slaves from Monticello and other plantations also gathered there on Sundays. Interestingly, Farley "may have brewed his own malt beverages, since in 1812 he sold Thomas Jefferson a large amount of hops," Stanton wrote.

Records suggest that Farley was the eldest son of Mary Hemings. That would have made him Peter Hemings's nephew, although Farley was only two years younger than Monticello's brewer, who was fifty-seven. Despite his age, Peter Hemings was appraised at the auction for the respectable sum of $100, probably due to his multiple skills.

On that January day in 1827, Farley made a single purchase. Records show that for one dollar, he bought "Peter. Old Man." As Stanton noted, "The token sale price suggests that the wish of his family members to purchase his freedom was recognized by those present at the sale." Peter Hemings lived out his days as a tailor in Charlottesville. No records indicate that he continued brewing. His legacy of making beer at Monticello, however, lives on in several ways.

THE ADVENT OF LAGER

In October 1852, Ernest Heinrich Hase stepped off the ship *Elsfeth* in New York to begin a new life in the United States.

Hase, thirty-four, was a native of Hanover, Germany. He worked as a joiner—a craftsman who joins pieces of wood into furniture and other articles. In New York, Hase's skills landed him a job with an upright-piano manufacturer, and he excelled sufficiently to win an award for his work on the instrument's sustaining pedal. In addition to employment, Hase found love in the city; he and Caroline Alexandrine Marie Dippel, who had left Germany with her parents and nine siblings in 1854, were married in May 1856, a day before her twenty-third birthday. The couple had several children before picking up stakes and moving to Charlottesville, where he would ply a new trade as a brewer of beer.

Hase was far from alone in his circumstances. Decades before the Civil War, a wave of Germans began flooding into the United States. They brought cultural traits such as business acumen, a discipline for hard work and a penchant for enjoying the fruits of their labors. They also brought lager beer.

"It is a new beverage, of German origin, but used everywhere, by everybody…in immense quantities," wrote Englishman David W. Mitchell in 1862 while living in Virginia. "It is a fermented liquor, made from malt only, I believe; and it must be drunk fresh, while effervescent. It affords another instance of an acquired taste; nobody liked it at first, but most people who use drinking-houses get to take it in surprising quantities. Germans have sworn to taking sixty glasses in an evening without being intoxicated."

Ernest Hase was among many German immigrants who started breweries in the United States. The Charlottesville Brewery on West Main Street included a bowling alley. *Photo reproduction from the 1874–75* Virginia University Magazine, *Alderman Library, University of Virginia.*

Although new in the New World, lager was old hat to Germans. The name comes from the word *lagern*, meaning "to store." Before refrigeration, brewing was a seasonal occupation. Summers were too hot for beer to ferment properly, plus the heat would spoil beer quickly. So the Germans stored their spring brews in mountain caves during the warm weather, or so we are told by centuries of beer lore.

A funny thing happened. While the casks sat, the yeast settled. A clearer beer emerged, and the extra time in storage helped condition the lager. This was a defining difference from ales, where the yeast fermented on top of the brew, yielding fruity esters and leaving a cloudy appearance. In addition, Germans were beholden to the Reinheitsgebot of 1516, which specified that beer could be made only of barley malt, hops and water (yeast was not fully understood at the time but was added later as the fourth essential of brewing).

Mitchell's remark that lager was made "from malt only" puts into contrast the diverse ingredients being used by Americans. As mentioned earlier, Thomas Jefferson and Peter Hemings were experimenting with malting corn for brewing. Spruce and persimmon beers were common. One Central Virginian recorded in his daybook a beer recipe using ginger, molasses and allspice. And an 1805 recipe even recommended making beer and ale from pea shells. "No production of this country abounds so much with vegetable saccharine matter as the shell of green peas. A strong decoction of them so much resembles in order and taste an infusion of malt (termed wort) as to deceive a brewer."

LAGER: AN "ACQUIRED TASTE"

Lager—clear, crisp, sparkling and golden—was a quickly "acquired taste," as Mitchell put it. Still, it wasn't everybody's cup of tea. R.T.W. Duke Jr., a famous Charlottesville attorney, recalled drinking his first glass of lager. "I can't say I liked it then or since," he wrote.

Duke's introduction to lager came at Hase's brewery. In 1868, Ernest had purchased the former Addison Maupin house—later known as the William Faulkner House, now the home of the Miller Center of Public Affairs on Old Ivy Road—and forty-one acres for $9,000. Duke recalled that Hase "had a brewery on the site…about a quarter of a mile in the rear of the house." Eleven months later, the family sold the home and moved to West

Main Street, where they set up a commercial brewery, ten-pin bowling alley and beer garden.

Lager had another foothold in town. Author James Alexander, in his memoirs spanning 1828 to 1874, described "a lager beer manufactory" operating in the rear of 101 East Main Street. The large, double-brick building housed a boot and shoe maker, A. Moser, and a confectioner, C.H. Wingfield. "John A. Marchant built this house and for several years did a mercantile business in it," Alexander wrote. The lager brewery was replaced by a painter and glazier, B.F. Hawkins.

The exact date and other details of that brewery have proved elusive, but Hase's commercial endeavor can be traced to 1871. An issue of the *Virginia University Magazine* carried an advertisement for the Charlottesville Brewery, claiming, "Students will always find finest brands of CIGARS, BEST WINES and FRESH, GOOD LAGER BEER." Ads in the 1874–75 and 1875–76 issues of the magazine name Ernest H. Hase as proprietor of the Charlottesville Brewery on University Street, but ale instead of lager is promoted. (A note: University Street, University Avenue and West Main Street are actually the same general stretch of road, going by different names at different spots and times.)

Trouble found Hase in 1875. Records show that he was indicted in August for selling ardent spirits without a license. The following month, prosecutors dropped the case. By 1880, Hase had moved back to New York to work on pianos; he and Caroline remained married, and she prospered in the saloon business in Charlottesville. Ads in the 1879–80 issues of the *Virginia University Magazine* show Henry Hase, the couple's second-oldest child, running the Old Dominion Saloon and Restaurant and selling Everts' Celebrated Bottled Beer. The location is simply University Avenue, but given that a ten-pin alley was attached, my guess is it's the same spot as the Hase brewery. An 1880 business directory lists E.H. Hase with an ale brewery and "piano mfr" on West Main Street.

Caroline Hase continued in the saloon business until her death in 1895, although during her final years she was "practically an invalid," according to her obituary in the *Daily Progress*. "[She] conducted the business here successfully and was known for her honesty and business integrity. She was charitable and kind and had the respect and confidence of those who were associated with her and of our German population particularly."

Hase's property on West Main Street was sold in April 1896 to Michael S. Gleason, who owned the adjoining store. He immediately sold a portion of the lot to Henrietta Hase, Caroline's daughter. Two buildings were

Old Dominion Saloon and Restaurant

UNIVERSITY AVENUE,

HENRY F. HASE, Proprietor.

——:o:——

My Saloon is stocked with the finest WINES, LIQUORS and CIGARS, which are served in the very best style. EVERTS' CELEBRATED BOTTLED BEER for family use. All orders promptly attended to. At the restaurant can always be found all the delicacies of the season. Private and Club-Suppers a specialty. Believing the Students will appreciate an effort to serve them in the best style, I cordially invite a share of their patronage.

Respectfully, yours to call on,

HENRY F. HASE.

oct 79.

☞ TEN PIN ALLEY ATTACHED.

Henry Hase, the son of Ernest and Caroline Hase, operated the Old Dominion Saloon and Restaurant at the site of the former Charlottesville Brewery. *Photo reproduction from the 1879–80* Virginia University Magazine, *Alderman Library, University of Virginia.*

constructed, the Hotel Gleason (later the Albemarle Hotel) and Hase's Imperial Café next door, at 619 West Main Street. The businesses were consolidated in 1910–11; over the decades, the hotel deteriorated until a revitalization program gave it new life in the 1980s. In 2016, it housed offices and a head shop named Higher Education.

Town Ripe for Out-of-Towners

Although Ernest Hase's hometown brewing venture seemed short-lived, the town was ripe for out-of-towners in the late 1800s. Lager flowed from three of the most prominent brewing companies of the day: Robert Portner of Alexandria, Virginia; Bergner & Engel of Philadelphia; and Anheuser-Busch of St. Louis. Portner and Bergner & Engel were the first, arriving sometime between 1880 and 1888, when Charlottesville became an incorporated city. The soon-to-be king of beers came later and stayed only briefly; the 1904–5 city directory puts the offices near the C&O rail yard. In addition, the 1898 directory lists the Charlottesville branch of Consumers Brewing Company of Norfolk at 309 South First Street.

To set the scene for the arrival of these breweries, the 1880s began with 4,500 inhabitants in the town, according to a state directory of businesses. Albemarle County was noted as "one of the largest and most fertile" in

GEORGE & WATSON,

Wholesale and Retail Dealers in

FINE TEAS, BRANDIES, WINES and WHISKIES,

FANCY AND STAPLE GROCERIES,

—ALSO—

English Pickles, Sauces, Catsups, English and Scotch Ale, Brown Stout, &c.,

No. 3 BANK BUILDING, MAIN STREET, CHARLOTTESVILLE, VA.

Robust beers such as stouts and Scotch ales were no strangers to Charlottesville in the 1800s. *Photo reproduction from the 1883–84* Virginia University Magazine, *Alderman Library, University of Virginia.*

the state with "scenery unsurpassed." The Chesapeake & Ohio and Virginia Midland Railroads were bustling, having built machine shops and roundhouses. Mills, a foundry, a tobacco warehouse, factories producing cigars and carriages and some mining characterized the area's industry. The Monticello Wine Company (managed by the father-in-law of Edward W. Hase) produced wines "equal to any in the country," and Albemarle pippin apples were enjoying international reputation and demand.

Enter Portner and Bergner & Engel. The 1888 Charlottesville directory puts the former on University Avenue and does not name an agent—at this time, the beer depots were run like franchises rather than being owned outright by the breweries. The latter was located on Green Street near the C&O railroad.

Bergner & Engel, at one time the third-largest brewery in the country, would disappear from the city directory by the following year. But Portner had staying power, not only in Charlottesville but also throughout the South. The brewery was the most successful in a string of businesses launched by Robert Portner. In 1853, he immigrated at the age of sixteen to the United States from Rahden, a small town in Westphalia, and joined his family in New York. He saw opportunity in 1861 in Alexandria, which was largely deserted except for Union troops, and he opened a grocery store with a partner. Beer proved to be one of the best-selling items, so Portner and others started a brewery.

Largely by chance, Portner became sole owner of the brewery in 1865, although he knew little about making beer or the beer business. After some

Here's a Pointer for you.

MARK!

PORTNER'S HOFBRAU
BEST AMERICAN EXPORT BEER

ROBERT PORTNER BREWING CO.,
CHARLOTTESVILLE BRANCH, - **D G COWBIG, Agent**

Charlottesville was among many cities in the South where Robert Portner Brewing Company of Alexandria maintained a presence. *From the* Daily Progress, *Albert and Shirley Small Special Collections Library, University of Virginia.*

initial bumps—and thanks to skyrocketing demand for malt liquors in the postwar years—the brewery began to succeed, initially with ales, not the lagers of his countrymen. A cream ale and a porter were two of the brewery's early mainstays. By adapting experimental air-conditioning and refrigeration techniques to suit the practical needs of a large brewery, Portner forged into the vanguard of beer producers and established branches and depots throughout the South, including the one in Charlottesville.

From 1888 to sometime before 1904, F.J. Lilienfeld was the city's Portner agent, with offices at the corner of Water and Fourth Streets for most of that time. Lilienfeld was the son of German immigrants who came to the United States from Hesse and lived in Michigan before coming to Albemarle

County. N.B. Lilienfeld, his father, was listed as a thirty-seven-year-old merchant in the 1870 census.

Typically, Portner depots were masonry structures, sometimes costing up to $50,000, built specifically for the company's purposes. They were located near railroads to facilitate shipment of large casks of fresh beer that the agents bottled and distributed. A cold storage room held beer waiting to go to market, and a stable and wagon shed housed transportation. Bottles were increasingly common, thanks to advances in manufacturing technology, and the trains often carried empty bottles as well as beer. Fires also were common—they claimed depots in Goldsboro, North Carolina, and Richmond, Virginia—and the Charlottesville facility burned in 1904. By this time, Portner had moved away from private agents and owned many area branches. William W. Payne was Charlottesville's depot manager in 1904–5, followed by Dennis Cowhig in 1906–7 with offices at 603 West Main Street.

The early Portner ales were joined by lagers, with Tivoli ("I Lov It" spelled backward) and Vienna Cabinet leading sales. Tivoli's creator, master brewer Paul W. Muhlhauser, also developed the company's first bock beer and a "Culmbacher" beer. The brands proved popular, for in the years from 1880 to 1902, the company increased its annual production in Alexandria from 600,000 bottles to 1.5 million bottles, and five years later, capacity at the central bottling plant was pegged at 20 million bottles.

FORCES OF PROHIBITION SURGE

While sales were increasing, so was a tide of sentiment that would end Portner's existence and dramatically change American beer culture for the next century. The forces of prohibition were on the move. It would be 1920 before the country went dry, but Charlottesville proved to be in the forefront of temperance by going dry in 1907 through a "local option" provision of state law.

The battle was pitched, and the stakes were high, particularly for those German Americans who depended on beer and other alcoholic beverages for their livelihood. "Prohibition menaced not only the brewers and the men on their payrolls, the large number of saloon and beer-garden owners and liquor dealers; it would also deprive the German clubs of their major source of income, the profits from beer sales at their get-togethers.… What German could conceive of meeting over soft drinks?" wrote Klaus Wust in *The Virginia Germans.*

The front pages of Charlottesville's *Daily Progress* reflected the intensity of the fight between the wet and dry factions. A letter from a dry proponent to the editors of the paper on May 30, 1907, blasted an unsigned article that accused drys of corrupting the electorate. "Let the author of this baseless innuendo say over his own name…who on our side has done aught to corrupt the electorate and let him put up the proof…[or] stay in his hole."

The blazing missive was signed by W.W. Lear, an official with the Anti-Saloon League. A Methodist minister from Nottoway County, Lear had spoken for years against the abuses of alcohol and saloons. He chaired the statewide Methodist temperance committee, and at the 1896 Virginia Methodist conference, he reported, "The gratifying progress of public sentiment relative to the subject of temperance…should encourage future exertion for the abolition of a commerce as ruinous to immortal souls as destructive to the physical well-being of men."

Voices were equally strident on the wet side, but practical matters also came into consideration. The front page of the Charlottesville newspaper's edition of June 3, 1907, carried a column of figures signifying "what local option or Prohibition, if passed, will cost Charlottesville." More than $11,470 would be lost in revenue from licenses to liquor dealers and restaurants, as well as from taxes and other items, the article stated. Just below it, another report referred to Covington, Virginia, which had gone dry the month before. "A circus visited town and not a drunken man was seen, not an arrest or fight, though such were common when saloons were open on a circus day."

Victors Shout, Church Bells Toll

The final tally on the first Tuesday in June 1907 was 430 votes for going dry, 390 votes for wet, giving the drys a 40-vote victory in the city. When the results were announced at 8:15 p.m. that evening, "loud shouts went up from one end of Main Street to the other" and church bells tolled. Tempers remained in check during balloting, remarkable given the heated debate.

"The nervous strain under which the men, women, and children labored for the past few weeks fell just little short of an hysterical frenzy," the newspaper noted. "The orderly manner in which the campaign and the election were conducted was a great tribute to the good sense, the calm judgment and the self-restraint of the people of Charlottesville."

The state as a whole would face the issue again in 1914. In Charlottesville, church bells tolled from 6:00 a.m. to 6:00 p.m. on voting day—September 22, 1914—and the city again cast its ballots to be dry, this time by a margin of 153 votes out of 545. Albemarle County residents, however, narrowly voted against statewide prohibition. Between headlines of "More Victories for Russians" and "German Right Was Encircled" regarding the world at war, the paper reported "Virginia Goes Dry by 31,500."

Indeed, at midnight on Halloween, October 31, 1916, Virginia joined seventeen other states to ban intoxicating beverages. "Big Victory Celebrated," the Charlottesville paper said in the next morning's lead headline. The nation as a whole would follow in a string of votes until January 1919, when Nebraska clinched ratification of the Eighteenth Amendment. Prohibition became official a year later. Although seventeen years would pass before beer would again flow legally from public taps in Charlottesville, the making and consumption of beer were not about to halt.

Chapter 6

"THE SEEDS OF A REVOLUTION"

You've read the tale of two taverns. Let's call this the tale of two homebrewers.

One occupies a unique place in the lore of the University of Virginia. William "Reddy" Echols attended Thomas Jefferson's university as an undergrad and obtained a degree in science and civil engineering. After a string of enterprising jobs—a railroad engineer, a mining engineer, a math teacher—he returned to UVA in 1891 to join the mathematics faculty.

An event in 1895 cemented his reputation for fierce determination. On the morning of Sunday, October 27—under crisp, clear autumn skies—the peals of the university's bells sounded the alarm for a fire that had broken out in the Rotunda, the university's centerpiece, designed by Jefferson himself. Faulty wiring apparently had kindled a blaze in the building's annex (a non-Jeffersonian structure), and flames threatened to spread to the main Rotunda.

Echols, in addition to teaching math, was supervisor of buildings and grounds for the school, a responsibility he discharged with characteristic vigor. Seeing his most cherished property in jeopardy, he acted quickly. An initial attempt to check the spread failed, so Echols "then climbed to the Rotunda Dome and hurled a sack of explosives on the connecting structure while flames leapt around him. The detonation was heard fifteen miles away but had no effect, and the Rotunda was left a gutted shell," reads the university's webpage devoted to the Echols Scholars Program.

Yes, Echols was so influential, colorful, beloved and gifted that UVA devoted one of its most prestigious programs to him. Begun in 1960, when

UVA was an all-male college, the Echols Scholars Program was established for academically ambitious students in the College of Arts & Sciences to live and learn in a common environment. In 2015, roughly 10 percent of A&S students were in the program.

Echols's legacy continues in another, less visible way. In the Albert and Shirley Small Special Collections Library at the university, you can check out fragile notebooks that contain everything from a romantic poem to mathematics equations, all written in a manly hand. One of the books contains Echols's experiments in homebrewing beer and wine.

EXPLODING BOTTLES, OVERFLOWING FERMENTERS

In an entry dated December 11, 1919, Echols recorded the details of his first brewing effort, noting that he followed closely a "receipt" of Dr. Charles Venable, a former UVA math professor. Echols used a one-ounce package of hops, boiled it for sixty minutes, strained it and poured in two bottles (one pint) of Maltine and one and a half pounds of brown sugar (Maltine was a pre-Prohibition product containing an extract of malted barley, wheat and oats and highly fortified by alcohol).

"Made a mistake pouring this hot solution in 8 gal jar, first then added 4 gals hot water," his notes say. A cake of compressed Fleischmann's yeast got fermentation going; two glasses of sugar and another cake of yeast followed. "Result was 7 gals of a weak beer.… Obviously not enough hops, Maltine or sugar was used."

Echols persisted, and like many homebrewers, he suffered exploding bottles and overflowing fermenters. Results improved. In April 1920, he brewed "an excellent stout—with good flavor and alcoholic strength." A batch brewed in August 1920 spent nine days in the vat and also earned glowing remarks. "This is a good musty ale with good alcoholic strength—but sweet. The wired corked bottles are flat. The crown corks kept perfectly." Another batch brewed in April 1920 spent eleven days in the vat and yielded 128 bottles. "This is an excellent well flavored strong ale—good and bitter," he wrote. "All consumed."

Echols also made parsnip wine at home, but beer dominates the entries. The last batch recorded in his book is dated May 9, 1921, when he capped 315 bottles of a brew that had "the most remarkable fermentation I have ever seen."

Beer No 8, May 9th 1921.

3 crocks 12+12+8 gallons —

12₁ spgr = 1.0698 percentage 17½ %

12₂ " = 1.0547 " 13½ %

8. " 1.0714 " 18 %

12₁ had 12 lbs - malt extract ⎱ about 14½%
 4 " Cane sugar ⎰

12₂ " 6 lbs malt ext ⎱ about 14%
 9 " sugar ⎰

8 " 8 lbs malt ext ⎱ 15%
 3 lbs sugar ⎰

Fermentation started Friday May 6, 1921

Sunday noon — Most remarkable
fermentation I have ever seen — After
rocky first foam — when skimmed 12
hours after yeast was added — no other
foam appeared at all — only surface bubbles
to small extent — but active movement.
In the 2 12 gallon crocks — the saccarimeter
sank to the bottom — less than 5% —
In 8 gallon crock — Sacc - at 7% —
Sunday May 8. 2:30pm -
(12)₂ spgr 1.02050, sacc = 1%

Bottled 315 bottles May 9th 1921

Best malt fermentation ever had —

William "Reddy" Echols, a prominent and popular math professor at the University of Virginia, kept detailed records of his homebrewing. *Photo reproduction, Albert and Shirley Small Special Collections Library, University of Virginia.*

A detail from Echols's homebrewing journal. *Photo reproduction, Albert and Shirley Small Special Collections Library, University of Virginia.*

It cannot escape notice that the dates of Echols's brewing coincide with nationwide Prohibition. He was not alone in his domestic activities. "While Prohibition formally ended the sale of intoxicating beverages from 1920 to 1933, it inspired an explosion in homebrewing. Beer consumption increased gradually during the 1920s, climbing to about 25 percent of its pre-Prohibition rate by 1930," reads an article in *Brew Your Own* magazine.

Sales of malt extract skyrocketed. "In 1926, 438 million pounds were produced and in 1927, 450 million. An estimated 90 percent of this syrup was used to brew 6.5 billion pints of beer," according to *Brew Your Own*.

Virginia's Mapp Act, which took effect in 1916, allowed for the purchase for personal use of three gallons of beer, one gallon of wine and one quart of whiskey every thirty days from outside the state. The National Prohibition Act, however, noted that "any room, house, building, boat, vehicle, structure, or place where intoxicating liquor is manufactured, sold, kept, or bartered…is declared to be a common nuisance." Enforcement was rare, but if caught and convicted, a homebrewer could face a fine of up to $1,000 and/or imprisonment of up to one year. Police had to search a private residence, though, which required a warrant indicating evidence the brew was being sold.

WAS HOMEBREW REALLY BEER?

There were other wrinkles. Actual consumption of alcohol was not illegal. Also, was homebrew actually beer? The act specified that beer, wine and malt liquors referred to beverages containing 0.5 percent or more of alcohol by volume. The Internal Revenue Bureau clarified in 1920 that homemade

cider and fruit juices were okay to exceed 0.5 percent as long as they were not intoxicating. "Nothing is said about home-brewed beers," noted a report in the *New York Times*. Something tells me that Echols's ale might have had a bit of a buzz to it.

Regardless, by 1933 the nation had had enough, and wheels turned to repeal Prohibition. That February, Congress allowed "near beer," or beer of 3.2 percent alcohol by weight or less, and stronger brews followed. In Charlottesville, voices in the newspaper, from the pulpits and on the streets lamented the loss of dry status when the Twenty-First Amendment was ratified on December 5, 1933. In Virginia, near beer became legal, but liquor was allowed only from out of state. "We may look for the wettest Christmas in recent years with our shrunken detachment of prohibition officers being bombarded on one side by smugglers crossing the Maryland border and on the other by our own enterprising bootleggers, who are ready to make the best of what time is left," the *Daily Progress* editorialized that December.

Virginia's going wet would not alter Charlottesville's status as a desert for locally produced beer. In Richmond, Home Brewing Company eased

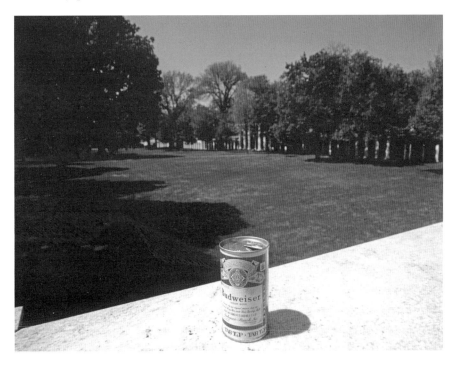

Remember tab tops? This can of Budweiser occupies a historic perch on part of the Rotunda at the University of Virginia. *Albert and Shirley Small Special Collections Library, University of Virginia.*

61

back into production with brews such as Richbrau. In Norfolk, Southern Breweries Inc. (originally Consumers Brewing Company) started an eight-year run in 1934 and cranked out Derby King and Southern beers. In Roanoke, the Virginia Brewing Company reopened in 1936 and sold Olde Virginia lager, "The Great New Beer with a Grand Old Name."

In Charlottesville, the days of depots bearing the beers of Portner, Anheuser-Busch and Bergner & Engel were long gone, and starting a hometown brewery was not on any entrepreneur's to-do list. The city directory of 1938 lists only one beer distributor, the Atlantic Company at 509 East Water Street.

There was certainly more than one watering hole, however. One of the most notable was the Cavalier, located on that hallowed stretch known as "The Corner." Gus Heilman, a former football player for UVA, became a co-owner in 1939 and helped the restaurant become a lively nightspot, much to the initial chagrin of his mother, a temperance union organizer. "She never thought her boy would have anything to do with beer," Heilman is quoted in the book *The Corner*. "And then one time she came down to visit me at the university. Well, it was a little hard at first—seeing me run a beer joint. But I think she took it OK."

Mainstream beers—Budweiser, Schlitz, Pabst—sold for twenty-five cents per bottle and fifteen cents draft at the Cavalier in the 1940s. Heilman was drafted to serve in World War II, and the restaurant closed in 1944, leading a writer for the *College Topics* paper to lament, "Our beloved Cavalier is to be torn down.…'No beer on the Corner' was the cry which went up as its portals closed for the last time."

The Pendulum Swings

By 1960, Charlottesville's population had grown to nearly 30,000 people (almost matching Albemarle County's 30,969), and four beer distributors were serving the community. Total enrollment at the University of Virginia was 5,047 in 1960—a decade before going coeducational and a far cry from the 23,732 undergraduate and graduate students in 2016.

Although small, the student body at UVA earned a national reputation for…well, before we go down that road, let's establish some context. For better or worse, consumption of alcoholic beverages has always had a place among college students, just as it has in society at large. The University of

Virginia was born in an era of hard drinking. "Drunken brawls among individual students frequently led to general riots," reads an excerpt from the 1911 *Madison Hall Notes*, a university publication. But then, "These conditions were not peculiar to the University of Virginia but existed in all American institutions of learning."

The effect of Charlottesville's temperance movement was lauded by school officials for decreasing student drinking. "Student public sentiment is becoming more and more opposed to drunkenness, and no student guilty of habitual drunkenness is tolerated in the society of his fellows," wrote James M. Page, university dean, in the 1910 *Alumni Bulletin*. "Organized drinking bouts, 'soirees,' celebrations after examinations, etc., are also rapidly going out of fashion."

The pendulum would swing. Young men in sport coats and ties flocked to The Corner and other watering holes, such as Carroll's Tea Room on Barracks Road (during one six-month stretch in the 1950s, Carroll's sold more than three thousand kegs of beer, according to *The Corner*). It was a tradition begun in the pre-Prohibition years, though, that would put UVA partying on the map.

Easters started in the late 1800s as a celebration following Easter Sunday. Students attended formal dances only after pledging they had not had

Easters at the University of Virginia was named the best party in the country by *Playboy* magazine. *Ed Roseberry, C'ville Images.*

a drink of alcohol after noon that day. Gradually, the focus shifted from abstinence to excess, and formality yielded to revelry. The freewheeling spirit of the 1960s added to the come-one, come-all festive atmosphere in the Mad Bowl, a large field with bowl-like shoulders that was hosed down to create a drenched pleasure pit. By the 1970s, "Many students and their dates wallowed about in mud holes, swilling grain alcohol drinks from large fruit juice cans," wrote Virginius Dabney in *Mr. Jefferson's University.* Young people flocked to Charlottesville for Easters, and *Playboy* magazine named it the best party in the country. Music was as much a part of the appeal as beer and booze. Local groups such as the Skip Castro Band joined national bands.

"Junior Walker and the All-Stars played in Mad Bowl. Little Feat and Bonnie Raitt played at [University] Hall," recalled an alumnus who attended the 1975 Easters. "Much beer consumed. It was a great time of my life." The following year, at Easters' peak, roughly fifteen thousand people showed up, and things became unmanageable. In the early 1980s, university officials terminated the event.

While Easters was in full flower, however, another bud was about to blossom in the student body. An undergrad in the nuclear engineering program named Charlie Papazian was, like his friends, drinking beer for effect rather than flavor. A six-pack in the early 1970s could be had for less than a buck. One day, however, one of Papazian's buddies told him about a neighbor who brewed his own beer. The man lived off Montebello Circle within walking distance of Papazian's apartment on Jefferson Park Avenue.

"We went to the guy's home. He invited us in. He went down in the basement by himself and came up with a couple of brown quart bottles. He said, 'This is the good stuff. It's been aged a year.' He opened that, and we were quite impressed," Papazian told me. On the spot, the man grabbed a three-by-five card and wrote down the recipe for Papazian. It was relatively primitive—one can of Blue Ribbon malt extract, five to seven pounds of sugar, yeast and water for a five-gallon batch—but that didn't matter.

THE JOY OF HOMEBREWING

Papazian was hooked. Not only did the beer taste great, but the process intrigued him as well. He began homebrewing, and word spread until folks were coming up to him and asking how to make beer. "I would just say, 'Come on over—this is how to do it,'" he said.

After learning about homebrewing while a student at the University of Virginia, Charlie Papazian went on to become a leader in the craft beer movement. *Courtesy of Charlie Papazian.*

After graduating in 1972 and moving to Colorado, Papazian taught homebrewing classes to others interested in learning about beer. Homebrewing technically was still illegal at the time because of a legislative oversight in the repeal of Prohibition, but President Jimmy Carter changed that by signing a law in 1978. That fed interest in what Papazian was teaching, and eventually he compiled the handouts he'd been distributing and put together a book called *The Complete Joy of Homebrewing.* First published in 1984 (an earlier version came out in 1978), it laid out the process in straightforward steps and reminded hobbyists to "Relax. Don't worry. Have a homebrew."

By this time, Papazian had realized the possibilities that existed for taking beer and brewing beyond the monolithic lagers of the macrobrewers. In 1978, he founded the American Homebrewers Association in Boulder, Colorado. He also started *Zymurgy,* a magazine for homebrewers, and the *New Brewer,* a magazine for small professional craft brewers.

A wave of interest in flavorful beer began sweeping the country, and homebrewers propelled the swell. Papazian's book took off and spawned several revised editions. Legions of homebrewers tested the professional waters, leading to pioneering companies such as Sierra Nevada, Bell's,

Stone and New Belgium. The Association of Brewers, which Papazian also founded, morphed into the Brewers Association, the not-for-profit trade group that today is the major force in representing craft brewing in the country. The American Homebrewers Association fed interest for hundreds of homebrew clubs, including Charlottesville's CAMRA (Charlottesville Area Masters of Real Ale).

"Charlie Papazian is the father of American homebrewing, and he continues to be important to homebrewers and the brewing industry today," said Jamey Barlow, a founding member of CAMRA.

Indeed, Papazian's homebrewing books have sold more than 1 million copies, and he has been in the front seat for the exhilarating ride that craft brewers have been on since Fritz Maytag bought and rebuilt Anchor Brewing Company in San Francisco in the late 1960s. In 2015, the Brewers Association announced that the nation had reached a historic peak with 4,144 breweries, more than the previous high of 4,131 in 1873. In mid-2016, that number stood at 4,656 operating breweries.

After thirty-seven years at the helm of the Brewers Association, Papazian announced in January 2016 that his role with the organization would shift away from his day-to-day, hands-on involvement as president. Founder and past president would be his new titles. Although industry folks around the country have heaped praise on him and his role in the craft brewing movement—calling him a "legend" and more—Papazian shrugs off star status. "The whole notion of being famous and a significant player is mostly how other people frame my world," he told a Michigan interviewer. "My world still has the same passion and enthusiasm [for homebrewing]."

More than 1.2 million Americans now brew their own beer, and about 45,000 belong to the American Homebrewers Association. For many, their motto is still "Relax. Don't worry. Have a homebrew."

Looking back, was Papazian's first taste of homebrew in Charlottesville responsible for a revolution? "The seeds of a revolution, that's for sure," he said and laughed.

Chapter 7

CRAFT BREWING COMES OF AGE

Paul and Burks Summers could hardly have known at the time, but when they opened the doors of Blue Ridge Brewing Company on Charlottesville's West Main Street in 1987, they were breaking ground in a movement that would change American beer culture.

Like Thomas Jefferson, Reddy Echols and Charlie Papazian, the Summers brothers were fascinated by the process—as well as the flavorful results—of brewing beer in small batches with traditional ingredients and methods. That same contagion was infecting homebrewers across the country.

In 1987, the United States counted 150 breweries in its borders. That was less than a decade from the all-time low (not counting Prohibition) of 89 breweries in 1978. Look ten years in the other direction, and the change is dramatic—1,396 breweries in 1997. Except for a slight dip in the mid-2000s, that trend would continue beyond 2015, when a new high was set in the number of breweries in the country.

Blue Ridge Brewing Company contributed to that momentum by being the first brewpub in Virginia (Chesapeake Bay Brewing Company, founded in 1982 in Virginia Beach, was the state's first commercial craft brewery but sold no food). The Blue Ridge owners had claims to history in other rights. Burks and Paul Summers were grandsons of William Faulkner, who was writer-in-residence at the University of Virginia in 1957 and 1958. Tony Contee, the third partner in the business and the brewpub's chef, added another bit of local color, for his family managed the venerable Michie Tavern.

Paul had been a merchant seaman and while in San Francisco had worked at a brewery and a restaurant there. Burks, known as "Bok," was the homebrewer of the two. Over beers in 1986, they devised plans to invest more than $200,000 in a restaurant with a brewery capable of producing four hundred barrels per year (one barrel equals thirty-one U.S. gallons).

They anchored their hopes in the Starr Hill neighborhood, known for its history of racial integration, the railway presence across West Main Street and its central location between the university and downtown Charlottesville. Pedestrians could see the stainless steel brewing tanks shining behind glass windows facing the street. Inside, patrons could sit at a long oak bar and sample brews from six taps.

Although the business was new, the approach was steeped in tradition. "What we're doing is going back to the old way of making beer," Bok Summers said.

LOCAL BEER IS A HIT

Of the four beers that anchored the lineup, two were lagers, which was unusual at the time because most microbreweries favored quicker-fermenting ales. Hawksbill Lager was a golden pilsner-style beer brewed with a combination of German (Hallertau) and Pacific Northwest (Willamette) hops. Piney River Lager, copper-colored with a richer malt profile, also used German hops, Northern Brewer for bittering and the noble Tettnanger for finishing. Two ales—Humpback Stout and Afton Ale (both named for mountains on the Blue Ridge)—rounded out the regulars. The remaining taps went to seasonals and rotating brews.

I remember visiting Blue Ridge shortly after it opened with my buddy Les Strachan. A discriminating beer enthusiast, Strachan had just spent a year in Germany with his wife, Nancy, and I had joined them for a week in 1986. Part of our Bavarian journey included sampling as many local breweries as possible, so it was with those memories fresh on our taste buds that we sampled Blue Ridge's beers. As I recall, we gave two thumbs up to the Summers brothers' brewing efforts.

So did others. "I've had many customers that have sampled the beers in Europe tell me that our beers fare very favorably with them," Bok said in a 1988 interview. "We're selling all the beer we can produce," Paul added.

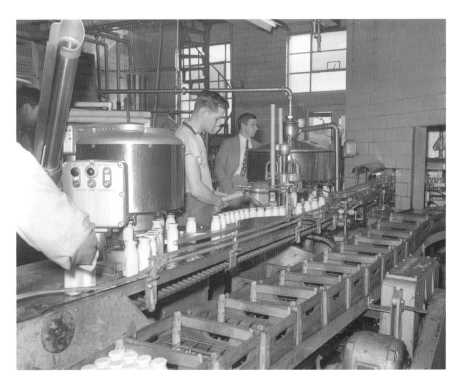

Above: The Monticello Dairy building on Grady Avenue would later house two breweries— Monticello Brewing Company and, currently, Three Notch'd Brewing Company. *Ed Roseberry, C'ville Images.*

Right: Charlottesville wasn't the only city to have a brewery named after Thomas Jefferson's home. The Monticello Brewery Company existed from 1955 to 1963 in Norfolk. *Photo by Lee Graves.*

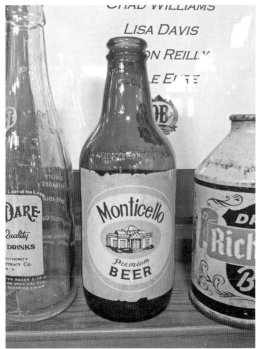

In 1996, the Charlottesville beer scene expanded with the opening of Monticello Brewing Company at 946 Grady Avenue. That address formerly housed the Monticello Dairy Building and would be the future site of Three Notch'd Brewing Company.

Monticello Brewing not only offered beers brewed by the father-and-son team of Vincent and Kevin Yeaton but also provided equipment for patrons to create their own batches. "There are a great deal of people in this community who brew at home," Vincent Yeaton told the *Daily Progress* in 1996. The "brew on premises" concept allowed folks to use Monticello's equipment for brewing, thus avoiding the mess and fuss of doing it at home. Customers could spend about eighty dollars to brew the equivalent of six cases of twelve-ounce bottles of beer. In addition, Monticello sold homebrewing supplies and raw ingredients—hops, barley malt and yeast. You could brew your own while sampling one of the Yeatons' offerings—Monticello Baume Ale (an American barleywine), Monticello Dunkelweizen, T.J. Lager and others.

Things really started to percolate as the decade advanced. A seminal moment in the scene occurred in 1998, when restaurateur Duffy Papas joined with Fred Greenewalt to open South Street Brewery in a former

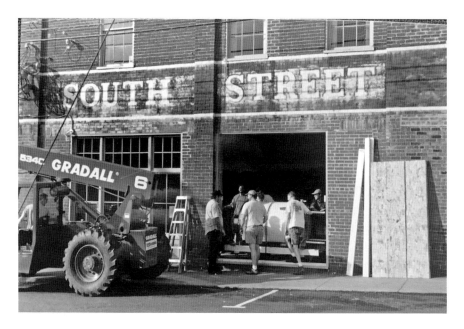

The crew at South Street Brewery loads tanks into the building in June 1998. *Courtesy of Jacque Landry.*

seafood restaurant near the Downtown Mall. They brought a gleam to the brick-and-wood bones of the building by putting a seven-barrel brewing system behind arched glass windows.

They needed a head brewer, and fortune smiled in the person of Jacque Landry. A veteran of the Colorado beer scene, including stints at Oasis in Boulder and Great Divide in Denver, Landry had moved to Central Virginia that June; his wife had been accepted into the graduate psychology program at UVA. Landry worried that he'd have to commute to Richmond to continue working as a brewer, but then he met Papas and Greenewalt.

Bringing Colorado Influence

"I hit it off with them, and the next thing I knew, I was going to be the brewer at a place that was just opening up," Landry said. The three saw eye to eye on South Street's brewing identity. "What they wanted, and what I ultimately did, was bring some of what I saw out in Colorado here."

Landry cloistered himself for several nights, devising a mix of offerings. Core beers would be Satan's Pony, an amber ale; J.P. Ale, a mildly hopped pale ale; and Absolution, an American strong ale. The lineup would also include a lighter beer—kölsch, saison or Helles, for example—and a rotation

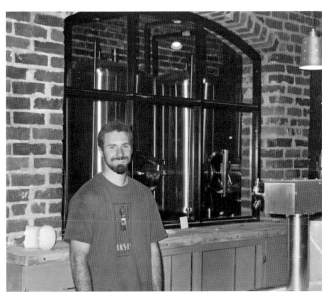

Jacque Landry was a veteran of the Colorado beer scene before taking over brewing duties at South Street in Charlottesville. *Courtesy of Jacque Landry.*

of other styles, like hefeweizens or Belgian ales. "Those were the base, and we evolved over sixteen years," Landry said.

South Street took off as Blue Ridge and Monticello faded. "Between 2000 and 2010, it was basically the place everybody went," Landry said. "We had a lot of grad students, a lot of law students, a lot of med students, and hosted a lot of events for those schools….I think overall we had a pretty wide demographic."

Not quite everybody was going to South Street. A young man named Mark Thompson was about to energize the beer scene in Charlottesville—and in Virginia—in unprecedented fashion. Thompson had grown up in the area, attended Western Albemarle High School and graduated from James Madison University with a biology degree. An itch for adventure spurred him westward, where he got a job in Oregon with the state's Department of Fish and Wildlife. "I was counting salmon on the Columbia River, and I realized that that really wasn't for me."

He went back to school, heading for a master's degree in biology at Portland State University. But some locally brewed beer that a friend brought to a poker game turned his head. The beer was from Nor'Wester Brewing Company, and Thompson applied for a job there. A part-time position led to a full-time job and a change in career goals.

It also led to an awkward call home. "I said, 'Mom, I'm not going to finish my master's degree. I'm going to bail on that—I'm going to be a brew master,'" Thompson told me in a 2013 interview. "There was this long silence. 'That's great son. What's a brew master?'"

From Oregon, Mark moved to Denver. He worked at the prestigious Mile High Brewing Company and developed a dry Irish stout that won a silver medal at the Great American Beer Festival. He also became friends with Landry, who was at Great Divide. Landry consulted Thompson before moving to Central Virginia, and the two kept in touch. Mark and his wife moved back to Charlottesville in 1998, and it wasn't long before a new opportunity developed through one of Mark's lifelong passions: live music.

MARRIAGE OF MUSIC AND BEER

In the 1980s, Mark Thompson had become friends with Coran Capshaw through their mutual love of the Grateful Dead and other bands. Capshaw bought a Charlottesville music venue called Trax in the early 1990s and

began managing a local group called the Dave Matthews Band. Capshaw's business savvy and DMB's musical awesomeness led to international renown for the band, mutual wealth and additional financial ventures for Capshaw, including one with Thompson.

The idea was a brewery/restaurant/music hall, and the spot that Blue Ridge had occupied at 709 West Main Street provided the right mix— brewing and kitchen equipment already in place and a concert venue upstairs. John Spagnolo, a Lynchburg native with extensive restaurant experience, headed the enterprise as owner, and Thompson managed the brewing operation. On Labor Day weekend in 1999, Starr Hill opened its doors.

The initial beer menu included the medal-rich Dark Starr Stout, an amber ale, an assertively hopped West Coast–style pale ale and a raspberry wheat ale. An Oktoberfest followed quickly, as did demand for the beer. Unlike South Street, which at the time kept all of its beers in-house, Starr Hill created a separate distribution outfit, Starr Beverage Company.

After the Monticello Brewing Company closed in 2000, South Street and Starr Hill were the area's lone craft breweries for more than a decade. At South Street, Papas bowed out of his role as part owner in 2001, which spurred Greenewalt to approach Landry with that opportunity. "My first response was, 'Are you crazy? Why would I want to do that?'" Landry recalled. "I'd never worked in a restaurant; I didn't know how it worked…. Basically, I think he would have closed it if I hadn't stepped in. But I did, and it worked out really well."

At roughly the same time, South Street saw the return of Taylor Smack with his wife, Mandi. Smack had interned at the brewery before heading to Chicago, where he studied at the Siebel Institute and later headed up brewpub operations for Goose Island Beer Company. As Landry moved more into a management role, Taylor Smack took over the head brewer's chores. Mandi helped in the restaurant and coordinated events. The quality of the beers led South Street to win the inaugural Virginia Beer Cup competition at Old Dominion Brewing Company in 2002.

At one point, Taylor Smack suggested that South Street build a production facility. He, Landry and Greenewalt visited an industrial park in southern Nelson County, a site that eventually would be the home for Blue Mountain Barrel House. It would have required a significant investment of South Street's resources.

"It was scary," Smack said. "Understandably, I couldn't get Jacque and Fred interested in it because it was my dream, not theirs. So that went by the

wayside." In 2006, the Smacks followed a longtime dream of having their own business and left South Street—with everyone's blessing—to found Blue Mountain Brewery in Afton.

CHANGE AFOOT AT STARR HILL

In the meantime, Starr Hill was going through significant changes. The brand, playing off Thompson's love of music, flourished with brews such as Jomo Lager, Amber Ale and Dark Starr Stout. Sustaining growth required broader vision. For a period, some beer was contract-brewed at Old Dominion Brewing Company in Ashburn.

Thompson's eyes eventually turned to Crozet, where a large manufacturing plant lay idle. ConAgra Frozen Foods had abandoned the facility in 2000, and the thirty-two thousand square feet of space fit Thompson's plans for expansion. The move, made in 2005, meant vaulting from a five-barrel system on West Main Street to a twenty-five-barrel setup in Crozet.

Growth exploded. Production edged over the fifteen-thousand-barrel mark, the threshold for a regional brewery. Changes at Old Dominion led to Starr Hill becoming the state's largest craft brewery (a position it held until eclipsed by Devils Backbone in 2013). Thompson's role evolved as well, as he became not only the face of the brand but also an energetic advocate for Virginia's craft beer community. "He and Kristin [Mark's wife at the time] really did a lot of legwork in terms of evangelizing craft beer in this area," said Landry.

Bumps emerged along the road. In 2007, distribution ambitions led Starr Hill to sign a deal with Anheuser-Busch that gave the macrobrewer an option to buy a 25 percent stake in the business. The plan was for Starr Hill to grow over the course of a decade into a national brand. "We want to be the next Sierra Nevada," Thompson told the *Daily Progress* at the time.

Expectations never materialized. Anheuser-Busch merged with InBev in 2008 and ended the deal with Starr Hill in 2011. Although national distribution proved elusive, national recognition didn't. Thompson achieved peer status among industry movers and shakers, and Starr Hill beers repeatedly earned medals at the Great American Beer Festival, World Beer Cup and elsewhere. In the Old Dominion, Thompson continued his craft beer advocacy, particularly in raising awareness of brewers' entrepreneurial spirit, and became chairman of the Virginia Craft Brewers Guild in 2014.

Internally, Starr Hill was going through major changes. Thompson's role as the face of the brand and voice of the craft cause took him further from hands-on brewing and day-to-day management at Crozet. In addition, the explosive growth in volume—from roughly four thousand barrels in 2007 to more than twenty-two thousand barrels in 2013—was outpacing capacity and upkeep of the infrastructure. "It was a tumultuous time with turnover and rapid growth," recalled Levi Duncan, who worked at Starr Hill from 2010 to 2014 and was lead brewer the last three years.

John Bryce also witnessed firsthand the dramatic swing at Starr Hill. He'd worked at Old Dominion and started his own brewery in Blacksburg before coming to Starr Hill in 2006 as part of the original team in Crozet. The staff was small and the experience intimate. "We had a lot of fun getting that brewery up on its feet and starting to produce all of the bottled beer to the point they cut the Dominion contract."

Bryce left in 2007, just before the Anheuser-Busch deal, to attend brewing school in Germany. He returned to Starr Hill in 2011. "When I came back, it was a very different company. It had changed a lot from Matt [Reich,

Charlie Papazian (center) of the Brewers Association joined (from left) Starr Hill co-founder Mark Thompson, Nate Sadler, John Bryce and Matt Briggs at the Crozet brewery in 2008. *Courtesy of Mark Thompson.*

brewer], Mark and I to like fifty employees. That being said, things were not in good shape. The infrastructure wasn't there, in terms of utilities and equipment. The level of expertise wasn't there."

Thompson was not unaware of the needs. In September 2011, he hired Brian McNelis, a longtime Anheuser-Busch executive who had been plant manager of the Williamsburg A-B facility, as Starr Hill's vice-president of brewing operations. One month later, Robbie O'Cain came on board as a brewer. Bryce and McNelis started working together to resuscitate the brewery, both in terms of mechanical upgrades and consistent brewing quality.

"Brian and I spent about a year and a half putting out fires," Bryce said. "We made drastic improvements—we had to. Honestly, I think it would've gone out of business if we hadn't." By early 2014, when Bryce left to pursue other business opportunities, he felt that a lot had been accomplished. "We had really just done a complete overhaul of the company in a lot of ways. And it was fun—it was exhausting, but it was fun."

During that time, a different culture was emerging at Starr Hill. The brand's strong association with live music came into question. "If you weren't attending a live jam band concert, perhaps you weren't getting some of the imagery," McNelis said in a *Virginia Craft Beer* magazine article.

THE NEED TO REINVENT

"What we realized, with humility, is that we need to reinvent ourselves and reintroduce ourselves to a lot of our existing customers and to new customers," McNelis told me in a 2015 interview. "So, we decided we need a new image, a new look."

The most significant change in direction came on February 16, 2015, when Thompson gave his notice, through e-mails and a posting on the company's website. "I have enjoyed being in the craft beer business for 23 years ever since I first went out west to learn the trade as a brewer. In 1999, I founded Starr Hill, and the brewery helped to pioneer the Virginia craft industry. Starting out in the Starr Hill Music Hall, the brand never strayed far from our love of craft beer and live music. After 16 years, I have now decided to retire from Starr Hill Brewery to pursue other opportunities in my life."

The notice took many people by surprise. "It looked sudden to people on the outside, but it really was not," McNelis said at the time. "Mark had

been in it a long time. Mark was the central figure for the Starr Hill brand for a good ten years, and he did a wonderful job as an entrepreneur of building this brand. He had to be marketing guy, brewing guy, production guy.… Then with things changing so much, I think that he just decided, 'You know what, I've had a good run.' And he decided to retire—and it was totally his call—and chill out for a while."

I caught up with Thompson in November 2015. We sat outside at Pro Re Nata Farm Brewery, and our conversation was repeatedly interrupted by folks greeting him, asking about him and approaching him as if he were, well, a star. Thompson emphasized to me that he decided to retire from Starr Hill because he "wanted to go out on top" and because there were other goals he wanted to pursue.

A similar sense of wanting to move on had surfaced at South Street Brewery. Greenewalt and Landry began testing the waters in 2014 to sell the brewpub. In February, they contracted with Taylor Smack to use the Blue Mountain Barrel House facility to brew South Street beers for distribution. But the brewpub would close, and in early July 2014, Greenewalt and Landry had a little sendoff party for themselves and select guests. "Sixteen years is a pretty good run. We both have families," Landry told Charlottesville's *Newsplex*. "We started this in our twenties basically, and now we're not in our twenties anymore."

"It requires a lot of energy and enthusiasm. The energy part is starting to wane, at least for me," said Greenewalt. "It's time to move on." Greenewalt cryptically said at the time that they had an offer from "an old co-worker." To no one's surprise, the Smacks announced a day later that they were purchasing South Street.

In a sense, Taylor Smack never left. Even after founding Blue Mountain, he would have dreams about brewing at South Street. "It is placed in my memory forever. Walking back in [to South Street] is like going home for me."

As these seminal operations were evolving, breweries along state Route 151 in Nelson County were establishing their own identity. Few anticipated, however, the announcement that came in April 2016 that jolted Virginia's craft beer community.

THE LOCAL SCENE

THE BREW RIDGE TRAIL

Maureen Kelley, economic development officer for Nelson County, was working to promote local vineyards when she had one of those lightbulb moments: if this works for wine, why not for beer?

She had noticed the growth and proliferation of breweries and saw an opportunity in 2009 to connect the dots to attract tourists and nurture their businesses. Working with Mark Thompson, then of Starr Hill; Taylor and Mandi Smack of Blue Mountain; Jacque Landry of South Street; and Jason Oliver of Devils Backbone, Kelley helped birth the Brew Ridge Trail. It extends from Charlottesville to southern Nelson County, and it now includes Wild Wolf in Nellysford and Blue Mountain's Barrel House production brewery, which had not been built at the time. "These brewers have such an amazing connection with one another," Kelley said. "It was easy for them and easy for me to bring them together to talk about the importance of the trail."

The brewers have put their heads together for collaborations over the years, ranging from an inaugural black IPA to a Belgian-style Quad in 2016 for which each pitched in a different ingredient.

One ingredient that sometimes goes under the radar is water, and the breweries directly under the brow of the Blue Ridge Mountains are blessed to have water particularly suited to brewing. "We have perfect water here. Perfect water," said Mary Wolf, head of Wild Wolf Brewing Company. Breweries along state Route 151 use water from wells coming straight off

the mountains, and in general the neutral pH and fairly low concentrations of ions provide some pluses for brewing.

Those conditions can provide a blank slate for brewers to build on. But situations vary even along the Brew Ridge Trail. At Blue Mountain Brewery in Afton, the water is "medium-hard, and that's our terroir," said co-owner Taylor Smack. In contrast, the water at Blue Mountain Barrel House in Arrington is much softer.

Different styles of beer have distinctive water profiles. Pilsners, for example, are characterized by soft water (low in mineral content) akin to the style's birthplace in the Czech Republic. The classic pale ales of Burton-on-Trent in England are renowned for very hard water, with high concentrations of calcium and magnesium sulfates.

Ami Riscassi, senior research scientist in the University of Virginia's Environmental Sciences Department, has been part of a team that has studied the area's watershed for years. She sees two basic factors contributing to the water quality in Nelson County. One is that the bedrock does not readily dissolve into the water, and the ions that are dissolved have the ability to neutralize acidic water (all rainwater that percolates to the groundwater is slightly acidic in the atmosphere). Also, the watersheds that feed the groundwater are relatively undeveloped. "So you don't get urban pollution issues…that would ultimately add ions to the water, making it less pure, less of a clean slate for the beer makers."

A clean slate reduces time and cost of treating or filtering water from a municipal source. And as Mary Wolf sees it, "If you don't have great water, I don't know how you produce great beer."

Here's a look at the six breweries that constitute the Brew Ridge Trail, starting in the city and moving along the path west and south. The Devils Backbone's Outpost in Lexington is part of the Shenandoah Beerwerks Trail, but I've kept the two Devils Backbone locations together for continuity. The Shenandoah Beerwerks Trail also includes breweries in Waynesboro, Staunton and Harrisonburg.

South Street Brewery

The current state of South Street sounds like the old bridal rhyme: "Something old, something new, something borrowed, something blue."

The blue is Blue Mountain Brewery, founded by Taylor and Mandi Smack in 2006. Both had worked at South Street and couldn't pass up the chance to

buy the brewpub when owners Fred Greenewalt and Jacque Landry decided to sell in 2014.

When the brewpub reopened that fall, there was plenty of old and new. The rustic brick-and-wood ambience, the cozy fireplace, the arched glass windows looking onto the gleaming brewing tanks and three original beers were all familiar. A snazzy updated logo, a retooled bar, a revised menu and a young brewer eager to create adventurous beers added zest to the mix.

More than anything, the Smacks succeeded in preserving the feel of South Street's heyday, when it was a prime destination for inner-city craft beer enthusiasts. Some of that has to do with retaining the founding ales—Satan's Pony, a malty amber; Absolution, an American strong ale; and J.P. Ale, a pale ale named after Charlottesville's Jefferson Park Avenue (commonly referred to as JPA). The first two are distributed beyond the brewpub; J.P. Ale is still available only at South Street.

Taylor Smack describes J.P. Ale as a beer "stuck in time." Although it is the only beer east of Montana to win a gold medal in the pale ale category at the World Beer Cup, at thirty-eight IBUs it now pales in comparison with the hop-heavy IPAs that dominate the market. (IBUs refer to International Bitterness Units.)

That doesn't mean South Street is behind the brewing times. Barhopper, a medium-body IPA at sixty IBUs; Hop Gothic, a wheat double IPA

South Street Brewery in Charlottesville is housed in a building that dates to the 1800s and once served as a grain warehouse. *Photo by Jennifer Pullinger.*

at "incalculable IBUs"; and even Roux, a red fifty-IBU IPA served on a nitrogen tap, cater to hopheads. Throw in a Russian imperial chocolate stout, a barrel-aged American wild ale, a sour grapefruit ale and a Helles lager, and you get an idea of the range of beers coming from South Street's brewer, Mitch Hamilton.

Before coming downtown, Hamilton worked at Blue Mountain in Afton for four and a half years. An Alabama native and graduate of the College of William and Mary, he actually started brewing on a much larger system, a fifty-barrel setup at SweetWater Brewing Company in Atlanta. The smaller system agrees with him. "At SweetWater, I never brewed a beer I could really call my own," Hamilton said. "That was occasionally possible at Blue Mountain, but Taylor's hand was still pretty heavy on recipe development. Here we have twelve taps, and half of them are mine. I've had so much more opportunity to create recipes here. It's exciting, and it helps me grow."

The relationship works two ways. "I believe he's thrived here because I do not oversee him," Smack said. "I say, 'Brew what you know we need and come up with other stuff—maybe let's talk about it, maybe not.' Sometimes I walk in here, and it's like, 'I've never heard of that beer.'"

Just as the beers are different from Blue Mountain, the menu reflects more of an upscale comfort-food orientation. "The quality at both is great," Smack said, "but we're able to go a bit more complicated and elegant here and still be comforty. That's mostly due to Mandi and our chef, Dan Zbiegien." Highlights include Wisconsin White Cheddar Cheese Curds, a Honey Chicken Cordon Bleu sandwich and a super-yummy Three Cheese Mac N' Cheese entrée. The pasta is handmade by Mona Lisa Pasta in Charlottesville.

By the way—that something borrowed? That's the mac and cheese. A little-known fact is that James Hemings, Thomas Jefferson's slave who accompanied him to Paris during TJ's years as minister to France, allegedly "borrowed" the recipe for macaroni and cheese while studying French cuisine. That most comforting of comfort foods is not an American original.

Starr Hill Brewery

When Starr Hill was founded, smartphones were not so smart, few people had heard of Al Qaeda and the average beer drinker couldn't tell you the difference between an IPA and a CPA. These days, any brewery that wants to keep its CPA happy had better be making good IPAs. It's part of being relevant, and that need is not lost on the folks at Starr Hill.

"We have to evolve and change by necessity," Brian McNelis told me in a 2015 interview. He retired as Starr Hill's CEO in January 2016 and continues as a consultant. "When you start in 1999 and go to now, in craft beer that's like 160 years when you consider the dynamism and the change in the market."

Think about it. In 2011—the last year before lawmakers passed a bill that would revolutionize the beer landscape in the state—Virginia counted 40 breweries. In early 2016, that number stood at more than 140.

For veteran breweries—and Starr Hill is the second-oldest existing craft brewery in the state—change must not undercut identity. You risk losing tried-and-true customers if you change a flagship beer or a marketing niche. Starr Hill did both. It revised the recipe of its flagship Northern Lights IPA in 2015 and used that release to introduce revamped package designs. That came on the heels of a redesigned tasting room, retooled tap handles and improvements to the brewing side of the Crozet plant—an upgraded lab, a hop cannon for improving hop flavors, an in-house canning line, additional tanks for fermentation and conditioning and more.

The move with Northern Lights was risky, but early returns indicate that it paid off. Sales increased by 40 percent in the months following its recipe change (and remember that IPAs are the most competitive style). Starr Hill's overall production exceeded twenty-six thousand barrels in 2015, and its reach extended to Tennessee, Alabama and Georgia to the south and Pennsylvania to the north.

It was a stable ending to a year that began dramatically. In February 2015, co-founder Mark Thompson, the face of the brewery and a longtime leader in Virginia's craft beer movement, announced his resignation (see details in chapter 7). "Mark and Kristin [Dolan, co-founder] were pioneers in Virginia. They built a great brand with a great identity and connection to music. But we're going through all that evolution, and the market's changing," McNelis said when I sat down with him and brew master Robbie O'Cain in June 2015.

O'Cain came to Starr Hill in September 2011, one month after McNelis. A former Anheuser-Busch executive and manager of the macrobrewer's Williamsburg plant, McNelis liked what he saw happening in the craft beer sector, particularly the small-business aspect. But Starr Hill needed to make up ground on several fronts. One of those was heeding the market's direction toward hoppy beers, and O'Cain would lead the way.

A native of Asheville, North Carolina, O'Cain started homebrewing after graduating with a chemistry degree from Hampden-Sydney College.

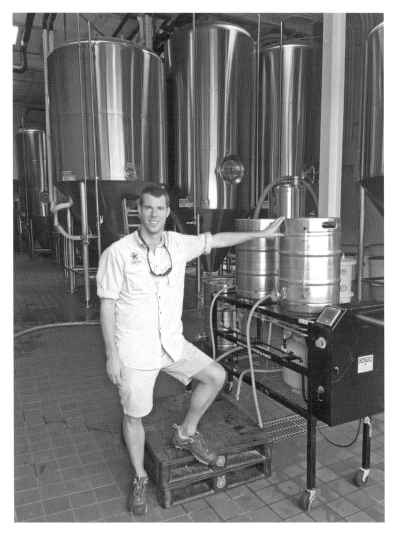

Brew master Robbie O'Cain has made his mark at Starr Hill Brewery not only by developing his own award-winning beers but also by reconfiguring existing recipes. *Photo by Lee Graves.*

He and some buddies started on a small Sabco system, and O'Cain's interest spurred him to learn more, through Siebel Institute's World Brewing Academy Master Brewer Program and at Doemens Academy in Munich.

He was fresh out of school when McNelis hired him. "I really didn't talk to a whole lot of other breweries [after finishing brewing studies]," O'Cain said. "Being able to see that this is where we wanted to go and this is where

we are—and this is the path to do that—there was a lot of opportunity to do that. So it was a great gig to sign up on."

He started as a brewer and then transitioned to lab technician—actually, before the lab was even built. He rose quickly, however, and soon was developing award-winning beers on the same Sabco system, transplanted from North Carolina. Little Red Roostarr, a coffee cream stout, was his first signature effort. Then came Whiter Shade of Pale Ale, a gold medal winner at the 2014 World Beer Cup, and King of Hop Imperial IPA, named best IPA in the state at the 2014 Virginia Craft Brewers Cup competition.

Developing those beers was different from redefining Northern Lights IPA. Its recipe had stood for nine years and was based on two iconic West Coast hops: Cascade and Willamette. O'Cain, promoted to brew master after Thompson's departure, simplified the malt bill and altered the hop profile by adding Columbus, Centennial, Simcoe and Falconer's Flight hops to the Cascade. He also used a process called "hop bursting," where massive amounts of hops are added late in the boil to emphasize flavor and aroma rather than bitterness. A hop cannon, which injects fresh hops into fermented batches to enhance aroma, and a centrifuge, which uses centrifugal force to separate out hop residue and other particulates to clarify beer without stripping flavor, have been added as tools in Starr Hill's shop.

"There are different techniques, but it's all about how do you come up with a creative solution to create some of these beers. There's really a tremendous amount of engineering that goes into all of this stuff," O'Cain said. "One thing we're open to is trying some of the creative techniques that the hop industry has come up with, as long as it creates a flavor profile that we're looking for."

A conspicuous example is the Reviver Red IPA. Five hop varieties—Citra, Simcoe, Mosaic, Amarillo and Columbus—create crisp citrus flavor and aroma but only a modest forty-five IBUs (the stylistic range of bitterness for India pale ales is forty to seventy IBUs). Four malts—two-row, crystal, wheat and chocolate—give an attractive garnet color and balancing sweetness.

At the other end of the hop spectrum, the Hopfetti Triple IPA had more hops (six varieties) than any other Starr Hill beer. Brewed in 2015 for the brewery's sixteenth anniversary, it was a fitting salute to the hophead-heavy market. At the same time, Snow Blind Doppelbock pays tribute to one of my favorite styles, with big malt, lager smoothness and 7.7 percent ABV, appropriate for the historic "liquid bread" created by fasting Bavarian monks. A "Heavy Rotation" series was launched in early 2016, part of an effort to release more new beers into the mix; in the same breath, the brewery retired

its German-style pilsner and Dark Starr Stout, its venerable mega-medal winner, from the year-round lineup.

Suggesting food pairings with the brewery's releases also aims to keep Starr Hill relevant. With Northern Lights, for example, try the chicken tikka masala, aged cheddar cheese and carrot cake.

Starr Hill has been stepping out as well as stepping up. In December 2015, plans came together for a new location in the Waterside development of downtown Norfolk. Collaborations also have increased. The 2015 collaboration involved seven breweries and included a trip to Ireland. "The collaborations are a sign of our pivot, our change in who we want to be," McNelis said.

Who does Starr Hill want to be? That question was easy to answer when Mark Thompson's signature was not only on beer bottles but also in the turn-it-up-to-eleven niche of live jam band music. As months ensued after that departure, a less personality-driven approach emerged that seemed set on maintaining relevance through hip packaging and cutting-edge brewing. That includes continuing to assess beers, even Northern Lights. "Five years from now, if it's still the same we'll probably need to look at it again," O'Cain said. "I think consumers are certainly beginning to understand and accept that we need to continue to develop."

Blue Mountain Brewery

Sit on the patio. Soak up the sunshine. Feel the sweet Virginia breeze tease your hair. Smell the savory scent of sausages, pizza and burgers. Listen to the bubbly chatter of friends and family. Look at the hop bines twirling up their strings and then keep looking up, up to Afton Mountain and the ridges that draw a craggy blue line on the horizon. And while you're drinking it all in, raise a glass of flavorful beer and toast your good fortune for being in a special place, on a special day, among special people.

Such is the feeling that Blue Mountain creates. While some breweries strive to offer a taste of place, Blue Mountain makes you feel like you're in a postcard someone will mail to a friend, saying, "Wish you were here."

For Taylor and Mandi Smack, opening Blue Mountain Brewery in Nelson County fulfilled a wish dating to the earliest days of their relationship. "Ever since we first met in Chicago, we had been talking about doing a business together," Taylor said in a 2015 interview at the brewpub.

Mandi smiled. "I think on our first date we ended up talking about a Laundromat brewery."

Blue Mountain Brewery in Afton has expanded steadily to include outdoor seating and reach the current capacity of serving 650 people. *Photo by Jennifer Pullinger.*

Blue Mountain is far from that. The restaurant has gone through several expansions and now seats 650 people. The taps have doubled to ten, offering staples from the first days—Kölsch 151, Full Nelson Virginia Pale Ale, Blue Mountain Lager—as well as seasonals and special brews such as Hibernator Doppelbock, Steel Wheels ESB and, if you time it right, Double Barrel-Aged Chocolate Orange Bourbon Stout. Most are brewed on-site and others at the Blue Mountain Barrel House in Arrington.

Much of the fare is locally sourced. The baguettes? From Goodwin Creek Farms, a Nelson County neighbor. The spicy sausage and bratwurst? Double H Farms, also in Nelson. The mushrooms on that sausage pizza? From A.M. Fog in—you guessed it.

Pizzas are a favorite at the restaurant, and there's a tale to them that defines the Smacks' business acumen, a blend of fulfilling personal dreams and bending those dreams to suit circumstances.

The couple met in Chicago in 2000. Taylor, a native of Lynchburg, Virginia, had come to the Windy City after some career soul searching. He graduated from Hampden-Sydney College in 1997 with a degree in English literature and a desire to write fiction. Instead, a job in the booming Internet bubble lured him to Charlottesville. He'd been homebrewing, and when the

office job proved mind-numbing, he volunteered at South Street Brewery and interned under Jacque Landry. He felt the call of professional brewing, so he went to the Siebel Institute of Technology in Chicago for a course in brewing technology. Fortune smiled when he landed a job there as head brewer at two brewpubs of Goose Island Beer Company, then a craft beer pioneer in barrel aging and style development.

"My whole career has been guided by Goose Island," Taylor said. "Everything I saw there was so far ahead of what other people were doing in the country."

A friend who worked at Goose Island introduced Taylor to Mandi, a Wisconsin native and graduate of Marquette University. She'd grown up around relatives who worked in the brewing business, so the two had plenty to talk about. They eventually moved back to Charlottesville and worked at South Street, where Taylor brewed and Mandi was a hostess and server. In 2004, they married.

The brewing chops Taylor learned at Goose Island made for creative forays at South Street—a bourbon barrel stout, a blended barleywine, a special pale ale. But Taylor and Mandi's early discussions of starting a business grew into a plan for their own place. They fell in love with Nelson County. "I thought, 'Man, this place is gorgeous.' You can go up to Humpback Rocks or hike the Appalachian Trail or go to Crabtree Falls," he said. Also, the model of vineyards as destinations spurred their design for a brewery in an agricultural setting.

They gathered investors and teamed up with co-founder Matt Nucci. But times were tight for the Smacks, dictating that they find a site with two lots—one for the brewpub and one for their personal residence. This was 2006, a time when the initial wave of microbreweries had ebbed, before farm breweries and well before a 2012 Virginia law would light the fuse for a craft beer explosion. "We went on faith," Taylor said.

"Some of our first customers that came in pretty much laughed in our faces and said this isn't going to work," Mandi added.

The initial brewery had a fifteen-barrel Premier stainless steel system. The first kitchen measured eight feet by sixteen feet. The first dining area sat sixty-four people. The first bar had five taps. The first menu consisted of one sandwich, one salad, parsnip soup and pizza.

They were slammed from opening day in October 2007. People were coming for the food as much as the beer. They couldn't keep up, so they cut pizza out of the menu. Big mistake. People yelled at them. "It was an interesting thing because it made me so mad," Taylor said. "In a city, if

someone would not like what we're doing, they'd just go somewhere else. Here, people would yell at us over and over again. 'You need to do this and that.' I would say, 'Well, don't come.' They'd say, 'I have to come. It's the only place around here.'"

Brewing beer, not running a restaurant, was their passion. The law at the time, however, said no food, no beer. "We did some soul searching, and we thought, 'We can keep doing just what we want, or we can do what everyone wants us to do,'" Taylor said. "That was the beginning of the massive ongoing evolution of Blue Mountain. We decided to do what other people wanted."

That evolution included growing Cascade hops for use in their beer. The first sign that went up on state Route 151 read, "Blue Mountain Brewery and Hop Farm." Initial attempts were fruitful but not plentiful, and the meager efforts attracted the attention of local hops guru Stan Driver.

"I was slightly offended when Stan came to me and said, 'Let me help you grow your hops' because we were the first ones doing it, and I was kind of proud of it. But we didn't have enough time, and I suck at growing things," Taylor said and grinned. "Our hops, since Stan took them over, are just so much better. We're good buddies."

In addition to the hops, the local flavor is undergirded by Blue Ridge mountain water, pumped from two wells, 350 and 500 feet deep. "Any brewer will tell you how important the water is. [Unlike city water], ours never changes," Taylor said.

The brew house, now under the guidance of Nucci, cranks out about 2,500 barrels per year, all of it for draft accounts, including South Street and the Barrel House. It's a mix-and-match arrangement—you can get South Street Anastasia's Chocolate Fantasy in the Arrington taproom, and you can get the Barrel House's Dark Hollow, a barrel-aged imperial stout, at Afton.

In addition to being at the forefront of Virginia's agricultural brewery movement, Blue Mountain was the first of the state's craft breweries to put beer in cans. Taylor and his brew team also have garnered some prestigious awards. Blue Mountain's Blue Reserve ale, a Belgian-style IPA made with fresh homegrown hops, won medals at the World Beer Cup and the Great American Beer Festival. In 2010 and 2011, Blue Mountain received back-to-back golds at the GABF, the only Virginia brewery to do so at the time.

Blue Mountain's growth has not come without a cost. Living next to the brewery, a financial necessity in 2006, became a mixed blessing as the couple became a family. They provide a presence that only owners can give, but the demands are ever-pressing. "As the years passed, I couldn't wash the dishes

without looking over to see if the parking lot was full. If the parking lot was full, I had to drop what I was doing and run over," Mandi said.

Still, the Smacks have made every effort to maintain focus on the passion that sparked their interest in the first place: making great beer. Taylor found himself so swept up in business matters that brewing had fallen by the wayside. "I said to myself, 'This is crazy.'" So every Monday you'll find him in the Afton brew house, working noon until midnight, brewing whatever is on the schedule.

And now he's able to chuckle about how their postcard setting once was a source of others' amusement. "When we started building, people made fun of us a little bit. Every other person would stop and say, 'What are you building here? Looks like a boat garage.'"

Wild Wolf Brewing Company

When Mary Wolf left her job with AOL in Northern Virginia and moved to the Wintergreen area in Nelson County, her list of "to-dos" included playing golf and bridge, hiking and relaxing—not starting a brewery. "If you had asked me when I retired from AOL if in ten years I'd be running a brewery, I'd ask you, 'What's wrong with you?'" she said.

Her son, Danny, had been following a passion for making beer and had just returned from brewing school at the Siebel Institute of Technology in Chicago. They opened a homebrew shop in 2010 on state Route 151 in Nellysford where customers could get growlers of Danny's beer. The business blossomed, one thing led to another and soon Wild Wolf Brewing Company was moving into a renovated historic schoolhouse. Since opening at that location in 2011, the brewery has become an essential stop on the Brew Ridge Trail, with a village of shops and event spaces, a restaurant specializing in savory barbecue and a pub that offers ales both adventurous and accessible.

Blonde Hunny, an easy-drinking Belgian-style blonde ale, is the bestseller, accounting for about 50 percent of distribution, Mary Wolf said in a 2015 interview. A more aggressive offering, Primal Instinct IPA, weighing in at ninety-five IBUs, has been gaining ground quickly, joining Wild Wolf Alpha Ale in a tandem of beers for hopheads. "We actually thought Primal would kill the Alpha Ale sales, but if anything they've increased, which has thrown me for a loop," Wolf said. "I have no idea why. The only thing I can think of is that people try one or the other and they like it, and then they try the other one."

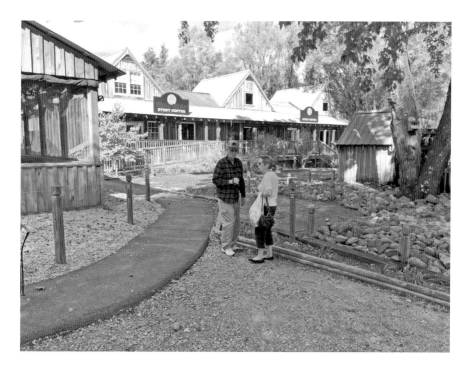

Mary Wolf and her son, Danny, have shepherded the growth of Wild Wolf Brewing Company from a small homebrew shop to a restaurant, bar and event site in Nellysford. *Photo by Lee Graves.*

Both are available in cans, as are Blonde Hunny and several other beers. Like many craft breweries, Wild Wolf is taking advantage of the increased acceptance of cans among consumers. About two-thirds of the brewery's annual production—about 4,100 barrels—goes into packaging, with the rest in kegs to be sold on draft. "When we first went into cans, our distributor was like, 'You aren't going to sell any beer,'" Wolf said. "We got our own canning machine in July [2015]. So we're canning sometimes three times a week. We're putting a lot of beer in cans."

Wild Wolf was the first Virginia craft brewery picked up by Loveland Distributing Company, based in Richmond. That association has led to some interesting offshoots—specially brewed batches for the Richmond Folk Festival, the Richmond Kickers soccer team and other partnerships. Those have broadened the brewery's exposure, as have the busloads of tourists exploring the beers, ciders, wines and distilled spirits in Nelson County. Most times, the Wild Wolf stop is sandwiched between Blue Mountain Brewery in the shadow of Afton Mountain and Devils Backbone's Basecamp Brewpub & Meadows below Wintergreen. "Each of the three breweries is incredibly

different, which I think makes it awesome because there's a good reason to try each one," Wolf said. "We all have amazing beer, and we're all doing things just a little differently."

Unlike the other two, Wild Wolf has no second production facility, and expansion was definitely under consideration in 2015. Brewing on the fifteen-barrel system has been pushed to its capacity, the main sixty-barrel fermenter is filled as soon as it's emptied and five trailers are used for storage on the ten acres. "We have pushed the limits as far as we can push them," Wolf said, "so we know in a couple of years we'll have a new brewery."

Still, the acreage has room for hops, spices, produce and chickens that go into the beer and food. Plus, the restaurant embraces the "farm to table" concept by supporting local farms, not only by purchasing goods but also by supplying spent grain to cattlemen.

Part of Wild Wolf's success comes from the accessibility of easy-drinking beers like Blonde Hunny. It's called a gateway beer, a door that opens for the Bud-Miller-Coors drinkers who are tasting their first craft beer. Or for wine enthusiasts whose palates are more accustomed to the tannins of grapes than the esters of ales.

Wolf herself once preferred wine to beer. She and her husband were regulars on vineyard tours, and they still have a three-thousand-bottle cellar. "But I don't drink wine anymore. I made a complete switch," she said. "I just have fallen head over heels in love with beer. Beer is just fine for me….As an ex-wine drinker, what I mostly loved about wine was the variety, and that you could have different wines from different parts of the world. It's interesting to know something about the region. But what happens is, with beer, they are so much more diverse. We can do just about anything with it."

As mentioned earlier, Wolf is wild about the water. "We can make any style of beer, starting with that base. There are not a lot of minerals and other things in the water so the brewers can add pretty much anything they want for whatever they're trying to accomplish. Very few places can say that."

It's not just the taste of the place that draws tourists and locals alike. With the Rockfish River burbling nearby and the oaks and pines bristling along the slopes of the Blue Ridge, local beer and natural beauty come together like wind and sky. "We've got this area of incredible natural beauty here that people are naturally drawn to, and from a beer scene I don't know that any other area in the state has that."

Devils Backbone Brewing Company

On April 12, 2016, Devils Backbone Brewing Company announced that it was being acquired by Anheuser-Busch InBev. The news made headlines and created a roar on social media. The harshest and most strident voices cried "sellout," declaring it a day that would live in infamy in the Virginia craft beer scene. Others offered congratulations to a business known for award-winning beers and toasted the company's ability to continue its meteoric growth as the state's most prolific homegrown brewery. Regardless, it was a defining moment for Devils Backbone.

In the eyes of co-founders Steve and Heidi Crandall, the decision reflected more than a yearlong process of exploring options to access funds needed to fulfill their vision for Devils Backbone. An initial two-year, $25 million shot in the arm meant upgrading the original one-hundred-acre site—the Basecamp Brewpub & Meadows in Nelson County—to include permanent camping, RV hookups, cottages, a distillery, an adult-friendly "Red Shed" and more. At the Outpost in Lexington, it meant added space for packaging

Brew master Jason Oliver has garnered gold medals and national prestige for Devils Backbone with beers such as Vienna Lager and Schwartz Bier, as well as through wide-ranging collaborations. *Photo by Lee Graves.*

and storage, a bigger taproom and outdoor beer garden, a barrel-aging program and eventually increasing annual capacity to 250,000 barrels.

In the eyes of brew master Jason Oliver, it meant working with a brewing company rather than a group of investors, enabling him to plug into a greater pool of resources, ingredients, expertise, equipment and facilities. "I advocated for ABI from the beginning," Oliver said.

In the eyes of some beer lovers, they had lost a vibrant member of a community that prides itself on being small, independent and local. Devils Backbone was no longer a "craft" brewery, according to the definition of the Brewers Association, the nonprofit trade group based in Colorado. Was Devils Backbone trading independence for cash and growth? Was its flagship Vienna Lager going to be dumbed down through mass distribution?

When I interviewed them in late April 2016, the Crandalls and Oliver were adamant that quality, consistency and autonomy had not—and would not—be sacrificed. They praised the "beer geek" sensibilities of ABI's High End division, which they will work under. "They don't want to change our DNA. They're not going to tell us what beer to brew. They're not going to tell us what states to go into," Steve Crandall said. "I tell the ABI brewers this: 'Why would you take one of the most award-winning craft beers in the country and change the recipe?' It's not going to happen. It just can't happen."

That beer is Vienna Lager, and it's at the heart of Devils Backbone's success. It accounts for roughly 55 percent of annual volume. It has won more awards than you can shake a shive at—gold at the Great American Beer Festival, gold at the World Beer Cup, gold at the Virginia Craft Brewers Cup, silver at the Australian International Beer awards and more. Beyond those distinctions, the Vienna Lager succeeds on other levels, offering an easy entry into great beer for mainstream drinkers while providing a complex, satisfying blend of caramel, toasted malt and subtle hops for the most discriminating beer geeks.

The story of that beer—and of Devils Backbone in general—begins on the slopes of Italy. Steve Crandall, a building contractor who was skiing there with Heidi, ended the day by drinking a yeasty wheat beer made by Weihenstephaner, a Bavarian brewery that dates to 1040. "It touched my lips, and I had an absolute epiphany," Crandall recalled at a business forum.

After exploring craft breweries in hot spots such as Colorado and Oregon, the Crandalls settled on a location to launch their own operation—one hundred acres under the brow of Wintergreen resort in the Blue Ridge Mountains. The Basecamp brewpub opened in 2008 with immediate impact, thanks largely to Oliver's brewing acumen. He not only masterminded the

Vienna Lager recipe but has also spearheaded forays into uncharted brewing territory (ever heard of pink Himalayan sea salt in a beer?).

A Maryland native, Oliver got hooked on flavorful beer in college. A visit to Richmond's Legend Brewing Company in its early days piqued his interest in the brewing process, but he didn't seriously consider a career in the field until he and his mother were in a bookstore and he saw the phrase *brew master* in a volume about unique professions. "I knew right then and there I wanted to be a brewer," he said.

A stint at Wharf Rat in Baltimore led to studies in the master brewing program at University of California–Davis; then his career path took him to Virginia Beverage Company in Alexandria and Gordon Biersch's location in Washington, D.C. Along the way, he developed a penchant for lagers, the fair-haired stepchild of the country's ale-dominated craft movement.

After several years in the structured atmosphere of the Gordon Biersch chain, he itched for more creativity. He spotted an ad for a brewer knowledgeable in German brewing techniques to join a Central Virginia startup. A visit to Devils Backbone sold him. He loved the mountainous setting, and he and Steve Crandall hit it off. The job was his if he wanted it, but he had one condition. "I told Steve, 'I'll take the job, just don't tell me what to brew,'" he said and laughed.

Crandall had already purchased an 8.5-barrel Japanese Miyaki system made especially for brewing German-style beers. It was in parts and pieces, however, and the assembly manual was in Japanese. No problem for Oliver, just as there was no problem putting together the beers to start the brewpub.

For the core brews, he developed Gold Leaf Lager, an American Helles; Eight Point IPA, an American IPA rich with citrus and pine notes from three hops; a weiss beer to satisfy Steve Crandall's Weihenstephaner leanings (originally called Wintergreen Weiss but changed to Trail Angel); and, of course, the Vienna Lager. For that beer, Oliver studied index cards he'd assembled over the years. "I put a lot of thought into it. But once we started brewing it, it didn't change much." The recipe uses Vienna, pilsner, dark Munich and caramel malts, plus Northern Brewer and Saaz hops. Alcohol by volume is 5.2 percent; the hop profile yields a delicate aroma and just enough bitterness (eighteen IBUs) to balance the malt.

Initially, the Gold Leaf Lager proved the favorite among Basecamp drinkers because of its gateway role for non-craft drinkers. But Vienna Lager offered broader appeal, and once the packaging took off, it became the backbone of the brewery. "I wouldn't have foreseen it to have the success that it has," Oliver said.

The crew from Devils Backbone Brewing Company poses with Charlie Papazian (far right) after winning one of several awards at the 2014 Great American Beer Festival. *Photo by Lee Graves.*

No one could have foreseen the business's rapid growth. The initial plan was to brew ten thousand barrels in the first ten years. That soon proved laughable. The business grew 278 percent between 2010 and 2013, leading to construction of a separate facility in Lexington, Virginia; in 2015, seven years after opening, Devils Backbone cranked out about sixty-three thousand barrels of beer. The Virginia Chamber of Commerce named Devils Backbone the Top Manufacturer in its Fantastic 50 ceremony in 2015 and 2016.

The Basecamp Brewpub—a big-beamed lodge with mounted trophies reflecting Steve Crandall's passion for hunting and love of the outdoors— had expanded even before the Anheuser-Busch InBev acquisition. An outdoor area includes a sheltered bar, a fire pit ringed by comfy chairs and a stage for live music. The historic Arrington railway depot was moved and renovated for private parties and other uses. A larger stage now handles bigger events, such as the Virginia Craft Brewers Fest, the

Derek Hornig mans some of the brewing chores at Blue Mountain Brewery in Afton. *Photo by Jennifer Pullinger.*

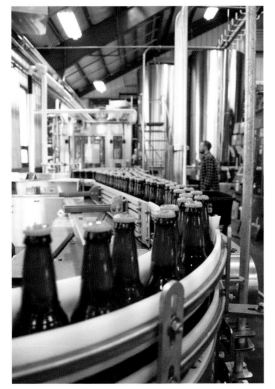

The bottling line at Devils Backbone Brewing Company's Outpost facility in Rockbridge County can fill 7,200 bottles of Vienna Lager in an hour. *Photo by Jennifer Pullinger.*

Left: Taylor Smack (right) consults with lead brewer Chad Dean amid tanks at Blue Mountain Barrel House in Nelson County. *Photo by Lee Graves.*

Below: Patrons of Pro Re Nata Farm Brewery take advantage of a pleasant day in Albemarle County. *Photo by Jennifer Pullinger.*

Banners display the artwork and ingredients of beers at Apocalypse Ale Works in Forest. *Photo by Lee Graves.*

Barry Wood grows and malts both six-row and two-row barley at Wood Ridge Farm Brewery. *Photo by Lee Graves.*

Taylor and Mandi Smack have steered Blue Mountain Brewery to a popular destination under the brow of Afton Mountain in the Blue Ridge. *Photo by Jennifer Pullinger.*

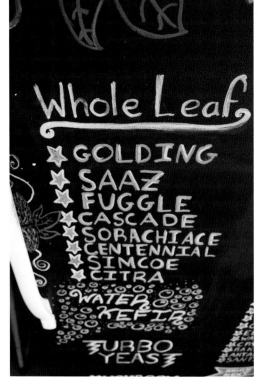

Whole Leaf

★ GOLDING
★ SAAZ
★ FUGGLE
★ CASCADE
★ SORACHIACE
★ CENTENNIAL
★ SIMCOE
★ CITRA
WATER
KEFIR

TURBO
YEAST

Experimenting with different varieties of hops, such as these sold at Fifth Season Gardening Company, is one of the appeals of homebrewing. *Photo by Jennifer Pullinger.*

Tiny lupulin glands in hops provide the resins that give beer its bitterness, as well as aroma and flavor. *Photo by Lee Graves.*

Champion Brewing Company's Shower Beer, a Bohemian-style pilsner, won a gold medal at the 2015 Great American Beer Festival. *Photo by Lee Graves.*

Steve and Heidi Crandall's love of the outdoors is reflected in the hunting-lodge ambience at Devils Backbone Basecamp Brewpub & Meadows. *Photo by Jennifer Pullinger.*

Like the best of pubs, Starr Hill's taproom in Crozet invites people to share good times with flavorful beers. *Photo by Lee Graves.*

The popularity of Wild Wolf Brewing Company's beers has stretched capacity to the point that founders Mary and Danny Wolf discussed plans for expansion. *Photo by Lee Graves.*

The lineup of beers at Three Notch'd Brewing Company ranges from flagships such as Hydraulion Red Ale to limited versions like Hansel & Kettle Imperial Oktoberfest. *Photo by Jennifer Pullinger.*

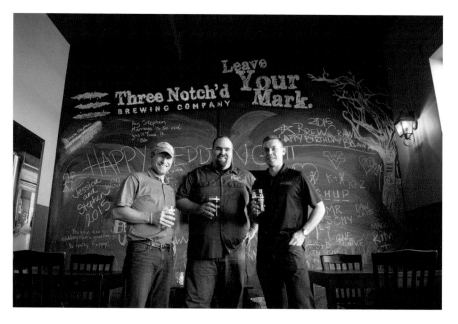

Three Notch'd head brewer Dave Warwick is flanked by co-founders George Kastendike (left) and Scott Roth. Derek Naughton (not pictured) also is a founder of the brewery. *Photo by Jennifer Pullinger.*

Brewer Mitch Hamilton has created exciting beers such as Acoustic Kitty Double IPA and Slippery When Wit at South Street Brewery. *Photo by Jennifer Pullinger.*

Above: Hunter Smith (right), founder of Champion Brewing Company, hired Levi Duncan to be head brewer in March 2014. *Photo by Jennifer Pullinger.*

Right: Tim Edmond (right) and Dan Potter are the founders and creative forces of Potter's Craft Cider. *Photo by Jennifer Pullinger.*

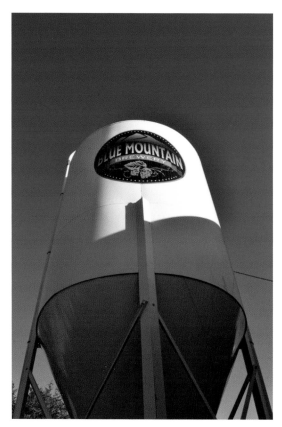

Left: This grain silo is part of the brewing operation at Blue Mountain Brewery, which produces about 2,500 barrels per year, all of it for draft accounts. *Photo by Jennifer Pullinger.*

Below: John Schoeb, co-owner of Pro Re Nata Farm Brewery, is a dentist and uses a medical term (meaning "as needed") for the brewery's name. *Photo by Jennifer Pullinger.*

Mary and Mike "Chappy" Chapple have adopted a simple philosophy—"beer for the people"—at Shenandoah Valley Brewing Company. *Photo by Lee Graves.*

The crew at Devils Backbone's Outpost facility includes (from left) Coey Jenkins, Justin Thompson, Nate Olewine, Josh Knowlton and Ben Shehan. *Photo by Jennifer Pullinger.*

Assistant brewer Tom Cook (left) helps Blake Sherman, head brewer, with chores at James River Brewery in Scottsville. *Photo by Lee Graves.*

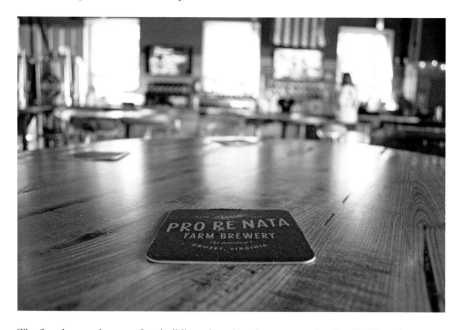

The five-thousand-square-foot building where beer is now served at Pro Re Nata Farm Brewery once was a Moose Lodge. *Photo by Jennifer Pullinger.*

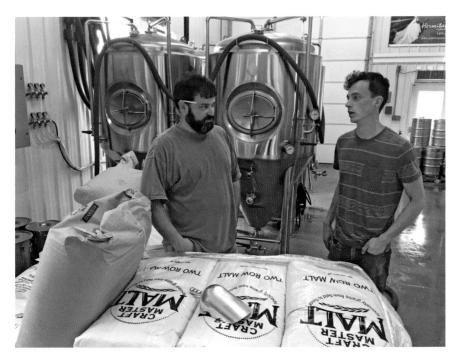

Owner Craig Nargi (left) talks with head brewer Christopher Fann at Stable Craft Brewing, which is on the Shenandoah Beerwerks Trail. *Photo by Lee Graves.*

Satan's Pony, a malty amber ale, is one of the founding beers at South Street Brewery in downtown Charlottesville. *Photo by Jennifer Pullinger.*

Barrel aging is part of the program at Potter's Craft Cider in the rolling hills northwest of Charlottesville. *Photo by Jennifer Pullinger.*

A welcoming sign and bags of barley in the window greet patrons at Redbeard Brewing Company in Staunton. *Photo by Lee Graves.*

What kind of beer do you serve a bear? Pretty much anything he wants (but check his ID). *Photo by Lee Graves.*

A volunteer provides a sample of Wild Wolf Brewing Company's beers at the 2015 National Beer Expo in Richmond. *Photo by Lee Graves.*

Above: Chris Kyle took over as general manager of C'Ville-ian Brewing Company in the spring of 2016, giving the operation a much-needed new direction. *Photo by Lee Graves.*

Left: Beer lovers flock to Starr Hill Brewery in Crozet each fall for the Oktoberfest celebration. *Photo by Lee Graves.*

Festy Experience and the Lava Festival. And a spacious campground draws nature lovers, bikers and hikers.

Through all of this growth, Heidi Crandall has served as the quieter of the two Crandalls but has guided much of the marketing side of the business. In 2015, she was named vice-president for branding. Hayes Humphreys, chief operating officer, has also been instrumental in the business's success.

These days, the Basecamp brewery serves as a pilot system, giving full rein to Oliver's creativity. Named the nation's top brewer in his category three times at the Great American Beer Festival and once at the 2010 World Beer Cup, Oliver has ranged far and wide in his brewing pursuits. A 2016 Adventure Pack featured collaborations with five breweries, ranging from Sun King in Indianapolis, Indiana, to Thunder Road in Melbourne, Australia. It was the Seven Summits Imperial Stout, brewed with Wicked Weed of Asheville, North Carolina, that included the pink Himalayan sea salt as a tribute to Mount Everest. A special American IPA debuted at Bank's Brewery in Wolverhampton, England, in 2015, and Devils Backbone supplied fifteen thousand barrels to English markets that year.

Foreign markets there and elsewhere definitely play into the plans for Devils Backbone. "We do think Europe makes sense at some point, but that's yet to be determined," Steve Crandall said in late April. "Canada's craft scene is about five or ten years behind what's going on in the U.S. There's a huge opportunity in Canada, as there is going across the U.S. with some of the beers that we've been successful with."

Although ABI's sales force will work in distant locations, Devils Backbone will have control in a five-hundred-mile radius, including New York. The Crandalls emphasized that seeing eye to eye with their new partners at ABI's High End has been their focus. "The vision of High End—their vision is our vision," Heidi said.

Devils Backbone Outpost (in Lexington, Part of the Shenandoah Beerwerks Trail)

The Crandalls started with a simple concept. "Our intentions were to build a local pub so the neighborhood could gather around it, and that was that," Steve Crandall said in a *Brewbound* article. They quickly discovered that the Basecamp brewpub could not keep up with demand. Devils Backbone was winning accolades, medals and public favor for the beers and the business operation. So they started scouting around for a production facility site.

They discovered fertile ground near Lexington. Rockbridge County owned twelve acres available for a brewery site and was willing to offset or waive certain fees to attract the $4.5 million investment. Construction of the first phase, a fifteen-thousand-square-foot facility, began in March 2011 with expectations of creating ten jobs in three years and producing thirty thousand barrels in ten years. Instead, more than two dozen jobs opened, two more construction phases had been completed before the ABI acquisition and the brewery cranked out roughly sixty-three thousand barrels in 2015, cementing Devils Backbone's status as the leader among the state's craft brewers. The operation was ranked seventeenth-fastest-growing business in the state, according to total sales, by the Virginia Chamber of Commerce that year. "It's crazy that we've expanded so much," said Nate Olewine, head brewer at the Outpost.

What's even crazier is that while expanding, the company continued winning accolades. At the 2014 Great American Beer Festival, after years of winning the top award in the small brewpub and small brewery categories, Devils Backbone won the award for Mid-Size Brewing Company and Brew Team of the Year.

The ABI acquisition set a new pace of growth. Plans called for purchasing an adjoining bowling alley property that would ultimately yield fifty thousand square feet of space. After moving some equipment around, including the original thirty-barrel system, the Outpost will have increased storage area, a larger taproom and more space for the outdoor beer garden.

Unlike the Basecamp's manual system, the Outpost is highly automated, with everything—from restricting dust during grain milling to using built-in lines rather than hoses—designed to increase efficiency and ensure quality. A lab is equipped with an autoclave, incubator, centrifuge and other equipment, and multiple tastings are held daily.

The Outpost has been going through about 4 million pounds of malt per year, and as with many breweries, the spent grain has been going to feed local livestock. "The farmers are knocking our doors down," Hayes Humphreys, company COO, said during a tour.

The industrial gleam and clatter of the main facility are complemented by the taproom's cozy, wood-paneled ambience and by the expansive views from the beer garden. Trivia nights, live music and other events add to the appeal of fresh beer. And there's plenty of that, from standards like Vienna Lager and Eight-Point IPA to less mainstream brews such as Spiderbite, a sessionable black wheat IPA, and Cran-Gose, a cranberry tart ale.

Blue Mountain Barrel House

Long before aging beer in barrels became a common practice among craft brewers, a beer named Bourbon County Brand Stout came out of Goose Island Beer Company's brewpub near Wrigley Field in Chicago.

That first batch was the brainchild of Greg Hall, son of Goose Island's owner and a true innovator. Using a half dozen malts and hops from the Pacific Northwest, Hall created a huge, high-alcohol imperial stout that had, in his words, "more flavor than your average case of beer." It achieved cult

Taylor Smack's barrel-aging program at Blue Mountain Barrel House reflects the time he spent in Chicago at Goose Island Brewing Company, a pioneer in barrel-aging beer. *Photo by Lee Graves.*

status, becoming "one of the most important beers in the history of American brewing," according to *Esquire* magazine.

That was in the early 1990s, and it wasn't long afterward that Taylor Smack came under Hall's wing in Chicago. Smack had spent time brewing at South Street Brewery in Charlottesville and was, in his words, "young and cocky and didn't know nearly as much as I thought I knew."

Hall was a tough mentor, but Smack learned the ins and outs of barrel aging. "It was really cool to be at the beginning of everybody latching on to that," Smack said. "Even when I came back to Charlottesville, I did a bourbon stout—nobody had ever done that around here. Now, I don't know a brewery that doesn't do barrel aging."

That includes Blue Mountain Barrel House in Arrington. The facility's barrel room, kept at a cool fifty-five degrees, has room for three hundred American oak barrels, all from distilleries like Maker's Mark, Four Roses and Heaven Hill. They're a beautiful sight, showcased behind glass windows.

The aging comes through in beers such as Dark Hollow, an imperial stout that gains notes of vanilla, along with the bourbon, from its time in those barrels. And Local Species, a Belgo-American ale with fruity flavors and an accessible 6.6 percent alcohol by volume. While those brews occupy a significant niche at the Barrel House, the place is primarily a production facility that supplies the bulk of Blue Mountain and South Street beers to market, from cans of South Street Satan's Pony to six-packs of Full Nelson Virginia Pale Ale.

Brewing in the ten-thousand-square-foot facility takes place on a thirty-barrel system that uses the parti-gyle technique. Wort—the hot liquid resulting from extracting the sweet fermentables from barley malt and other grains—from one mash can be used for separate batches of beer. "Originally it was built for doing huge-gravity beers, but we don't do that much anymore," Smack said, leaning over the mash tun with shift brewer Brian Goff. Now, the system is used mostly for blending hops—different varieties of hops go in separate kettles to be combined with the wort in various ways. A centrifuge adds to the brewery's ability to accentuate flavor over bitterness in that ingredient.

Cranking out the beers requires around-the-clock brewing three days a week. Annual production totals about eighteen thousand barrels. Some beers supplement the brewpub at Afton and others at South Street, but all of the packaged product comes from the Barrel House.

The towering fermentation tanks provide a gleaming view for geeks, tourists and local residents who flock to the Barrel House tasting room.

Outside, the view is just as engaging, with the Blue Ridge rising above rows of poles that grace the scenery with garlands of hops in season.

Those hop bines are the darlings of Stan Driver, one of the pioneers of modern hops cultivation in Virginia. He began growing Cascade and Centennial hops at Blue Mountain's Afton facility in 2007 and then expanded to Arrington when the Barrel House was built in 2012. It was a groundbreaking endeavor. "I'm not aware of anybody who was doing it on a commercial scale, at least publically," Driver said.

Now the focus is primarily on Cascade, which growers say is best suited for Virginia's climate. The Barrel House half-acre plot sports 560 crowns, all Cascade, which have a slightly different character from those grown at Afton (a lower percentage of cohumulone, an alpha acid analog, that basically means less harshness in the bittering agent). Driver has built a small shed for drying the hops before they go into the Blue Mountain beers.

The Arrington site was originally considered for the restaurant and brewery that eventually rose in Afton. The northern part of Nelson County served their farm brewery concept better and drew more people from Charlottesville. Because it's in an industrial park, the Arrington location again was eyed as a possible site when Smack advocated building a production facility for South Street. That idea never took shape, but when Blue Mountain's growth dictated expansion, Arrington finally got the nod.

As at Afton, sweeping views add to the perks for visitors and employees alike. "We kind of always looked for a great view," said Mandi Smack, Taylor's wife and the company's co-founder, in a 2015 interview in *Virginia Craft Beer* magazine. "Since this location was geared to production, it wasn't a necessity. But people do come out here to relax and check out the views. It makes coming to work a lot easier."

Beyond the Brew Ridge Trail

Champion Brewing Company

When Hunter Smith took stock of the beer landscape in the Charlottesville area in early 2012, he saw a way for his new brewery to stand out while fitting in. "There were obviously a lot of well-established breweries in Starr Hill, Devils Backbone and Blue Mountain—all of which I love to visit. But

in the marketplace, even in 2012, people were looking around for 'What's next? What's new? What haven't I had before?'"

So, Champion Brewing Company's initial crop of beers included a Berliner weisse and a gose. I must confess that my first gose ever was sampled in the Champion tasting room, and the blend of sea salt and mild tartness was revelatory—exotic, appealing and accessible. "Obviously, we had to let people know what a Berliner weisse was if they ordered a wheat beer," Smith said. "I think that's cool, when people come in here looking for something they haven't had before. And they might not like it, but that's OK."

For the record, a Berliner weisse (*weisse* means "wheat" in German) is characterized by mild sourness and tartness accompanied by a light, fruity flavor. As far as people not liking what Champion is offering, the record proves opposite.

Starting with a three-barrel brewing system next to the tasting room, Champion opened its doors in December 2012 on Sixth Street (within walking distance of Spudnuts, if you have a sweet tooth). Its Missile IPA, always intended to be its flagship beer, took off like a rocket. One year after opening, Smith and his co-workers expanded into a thirty-barrel production facility in Belmont called the Missile Factory, where annual capacity would jump to ten thousand

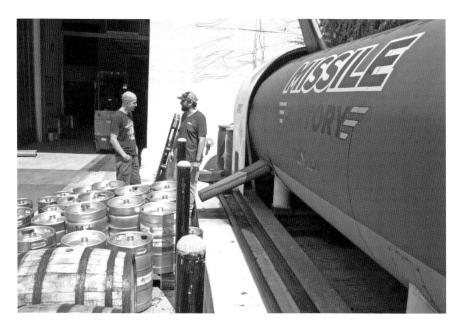

John Bryce (left), founder of the Lupulin Exchange, chats with Josh Skinner, lead brewer at Champion Brewing Company's Missile Factory. *Photo by Lee Graves.*

barrels. As 2015 drew to a close, Smith was considering a custom-built facility with even more capacity. "It's bonkers," he said with a smile.

Volume reflects only one facet of success. Champion gained recognition for its adventurous spirit with brews such as Loyd's Revenge, a chocolate oatmeal plum milk stout brewed in collaboration with Jason Oliver of Devils Backbone (the name borrows from the movie *Dumb and Dumber*).

Other collaborations plugged into Smith's passion for music, especially punk. Stickin' in My IPA, a West Coast–style rye IPA brewed with Simcoe and Falconer's Flight hops, came after he reached out to members of NOFX. Their song "Sticking in My Eye" starts with the line "When I look 'round, I only see outta one eye." Another band (and one of my personal favorites), the Hold Steady, collaborated on the recipe for Positive Jam, a spring ale made with coriander and lavender. The name riffs off the band's *Stay Positive* release (best track, in my humble opinion: "Navy Sheets").

Champion's stature took bigger steps through two competitions in 2015. At the Virginia Craft Brewers Cup that August, Smith, brewer Levi Duncan and other members of the group walked away with three medals—a gold for Killer Kölsch, silver for Tart Berliner-style Weisse and bronze for Stickin' in My IPA. "To hear our name called once was fantastic. And then three times, it was really kind of surreal. It was really great for us as a team," Smith said.

At the Great American Beer Festival in Denver the following month, a coveted gold was awarded for Champion Shower Beer, a Bohemian-style pilsner true to that lager's tradition of using all Saaz hops. (*Men's Journal* magazine included Champion among "20 Great American Beer Fest Winners You Never Heard Of.")

Duncan has played a large role in the beers' success. He and Smith became acquainted while both were aspiring brewers taking classes at Piedmont Virginia Community College. Later, at a tasting at Beer Run, Smith mentioned to Duncan, then working at Starr Hill, that Champion's expansion meant he'd need a lead brewer. Duncan asked what it would take to land the job. "Hunter told me, 'If you want the job, I'm not going to talk to anybody else,'" Duncan recalled, and he joined the team in March 2014.

Smith is a Charlottesville native, born a few blocks from the tasting room. Champion's décor reflects a bit of that hometown connection with photographs by local icon Ed Roseberry. One of the most striking is a 1965 shot of Chuck Berry rocking out in front of a University of Virginia crowd decked in sports coats and party dresses.

"I'm the only one in my family who didn't go to Virginia," Smith said. Instead, he majored in music at Northeastern University, followed by a stint

in a recording studio in Boston and a stretch as a touring musician. When his family purchased Afton Mountain Vineyard, he worked there until a yen for brewing took him to the Siebel Institute of Technology in Chicago for six months of intensive brewing education. "That was definitely my trial by fire."

Using a small loan, Smith started Champion as the 100 percent owner. His wife, Danielle, handles some of the business matters. As of December 2015, distribution ranged through most of the Old Dominion, including Northern Virginia, plus Washington, D.C., and all of North Carolina.

Champion now bills itself as Charlottesville's most progressive brewery. The spectrum of styles requires a commitment to informing consumers, and Smith stresses the value of educating his tasting room staff. Questions as simple as "How do you pronounce 'gose'?" need to be answered with authority (by the way, it's *go*-suh). "These guys have got to know as much as we do about what we're making, or else they're going to be stuck not being able to explain this experimental beer," he said.

He also is a cheerleader for craft beer, not only locally but also the industry in general. During an emotional public hearing in 2015 when the Albemarle County Board of Supervisors considered a land use amendment that might have helped land a national brewery, Smith was the only area brewer to speak. His message: Breweries bring jobs and revenue, plus the big beer companies help the local brewers, which have added dollars to area coffers through taxes and tourist visits.

One thing that draws tourists to Charlottesville and the Brew Ridge Trail is the diversity of beers, of breweries and of the experiences at each, Smith said. "From a tourist's perspective, you can come here and have a lot of different experiences by hitting breweries that are still in the same easy-to-access area, but it's very different."

Three Notch'd Brewing Company

Fate pulled a fast one on Dave Warwick when he started at Three Notch'd Brewing Company in Charlottesville. He had already formulated the concept for an IPA that would wave the flag for the brewery. At the heart of the recipe was a hop he discovered during a trip to the Pacific Northwest. "I came across this hop that I'd never heard of called El Dorado," recalled Warwick, head brewer at Three Notch'd. "There was only one brewery on the East Coast using it, and that was Flying Dog [Brewery in Maryland], for a seasonal. I just fell in love with the hop and its unique, peachy, tropical flavor."

When it came time to fire up the brew kettle, though, no El Dorado was available on the market. None. Zilch. Fortunately, Flying Dog had twenty-two pounds left from a previous batch. "That was enough to get the couple of batches going of 40 Mile."

Now, 40 Mile IPA, which is named for Jack Jouett's ride to warn Thomas Jefferson and others against capture by the British, accounts for roughly 45 percent of the brewery's business. The recipe includes other hops—Centennial, a touch of Cascade, CTZ and Willamette. At fifty IBUs and 6 percent alcohol by volume, 40 Mile IPA sits in the middle of the IPA bracket but earns high marks for its fruity aroma and drinkability.

Although 40 Mile IPA is the bestseller, Three Notch'd has earned the greatest distinction for other beers. At the 2014 Great American Beer Festival in Denver, Hydraulion Red, an Irish-style red ale, won a bronze medal; the following year, judges awarded it a silver in the Virginia Craft Brewers Cup competition. The name is a nod to the fire company started in 1828 by University of Virginia students. Many of the other beers—No Veto English Brown Ale (a gold medal winner at the 2015 Virginia Cup), Brother Barnabas Belgian Tripel Ale, Fan Mountain IPA—have historical or personal connections. So does the brewery's name, for Three Notched was the main east–west road through Albemarle County and for a time served as Charlottesville's Main Street. Three notches were chopped into trees to mark the way.

"One of the things we wanted to do was play off the historical nature of Virginia," said CEO George Kastendike as we sat savoring a pint with Warwick and Scott Roth in the brewery's tasting room on Grady Avenue. Kastendike and Roth co-founded Three Notch'd with Derek Naughton in the spring of 2013. "It struck me that not only is Virginia kind of central to our founding documents and things like that, but it also is central to everybody's sense of being and how you want to be successful every day.…Celebrating everybody's drive to be something special in their own individualistic way is the most important cultural piece of the marketing that we wanted to put together."

The brewery fosters that sense of community through collaborations, partnerships and just fun brewing. Getting together with Jason Oliver, brew master at Devils Backbone, yielded Hysteria Imperial Hoppy Brown Wheat Ale. Joining forces with Alistair Reece of Charlottesville's homebrew club, CAMRA, led to Bitter 42 English Pale Ale. And playing host to area hops growers produced brews such as Ten Farmers Harvest Pale Ale. That last beer has a special place in local brewing. The concept began in 2014 and played off the harvest ale tradition popular in the Pacific Northwest, where

Dave Warwick, head brewer at Three Notch'd Brewing Company, is surrounded by fans at the 2014 Great American Beer Festival in Denver, Colorado. *Photo by Lee Graves.*

hops are taken from the fields directly to the brewery for wet hopping. In Charlottesville, ten farmers delivered hundreds of pounds of fresh-picked hops for a ceremonial event in two successive years.

"The beer has almost a terroir to it, like wine," said Chris Gordon, owner of Charlottesville Hops. Terroir refers to the "taste of place" concept where local ingredients give a unique flavor. "You're tasting Charlottesville in this beer. I love that concept."

Three Notch'd beers span a spectrum of styles, but hoppy brews led to a bond among the founders. Roth had opened McGrady's Irish Pub in

2006, and his restaurant experience, combined with Kastendike's business aptitude and Naughton's social networking, provided the foundation for the idea. Although South Street brewpub had an established reputation, the three saw the need for a different brewery in the heart of the city. Over pints at the pub in early 2012, the three solidified a business plan but lacked a key element: a brewer. "None of us have any brewing experience, and that remains true," Roth said.

They ran into Warwick at the Virginia Craft Brewers Fest that August. Warwick had a solid background, starting as assistant brewer at Rock Bottom brewery and restaurant in Colorado and advancing to brew master at the chain's Arlington, Virginia branch. "One of the first interview questions we had for Dave was—we're all huge IPA fans—'What's your favorite IPA?'" Kastendike recalled. "And he said Bell's, [Ballast Point] Sculpin and one other. And it was like, 'OK, you're hired.' One of the things we told him was that we wanted to do our best to own the IPA category."

That's a tough target, given the popularity of the style and the seemingly infinite and excellent number of versions on the market. Brewing began on a twenty-barrel Metalcraft Fabrication system from Portland, Oregon, and doors opened on Preston Avenue in August 2013. Three Notch'd met its three-year forecast in the first seven months, added fermentation and bright tanks and hit the seven-thousand-barrel annual mark in 2015. The brand has its own distribution company and has opened satellite taprooms in Harrisonburg and in Richmond's Scott's Addition. Both locations have pilot brewing systems to develop unique beers, and they join a cluster of breweries in each city that creates destinations for beer explorers.

That sense of destination fit into their initial vision of the Charlottesville community of breweries as well. They saw the evolution of the Brew Ridge Trail and operations such as Devils Backbone, Wild Wolf, Bold Rock Hard Cider, Blue Mountain, Starr Hill and others. "We realized that people are coming to Virginia. They're staying in Charlottesville and driving thirty to fifty miles to see these breweries," Kastendike said. "This is an epicenter for history, and this is one of the most beautiful places in the world. Central Virginia is just renowned for its culture, and to not have a very successful craft brewery in the center of the city just did not seem correct for us."

Now Three Notch'd is part of the Shenandoah Beerwerks Trail, and like Jack Jouett, the brewery is living up to its own motto: "Leave Your Mark."

C'Ville-ian Brewing Company

The "red, white and blue" theme of this brewery on West Main Street reflects the military background of owner Steve Gibbs. After a decade in the U.S. Army, Gibbs became a civilian (hence the brewery's name) and started pursuing his passion for making beer. In 2016, however, he returned to the Middle East, leaving the operation in an uncertain state.

The brewery opened in April 2014 and got off to a bumpy start, with business below expectations. In addition, initial batches received some less-than-complimentary reviews, citing possible contamination and carbonation issues.

The business side also hit potholes. Doors were locked when signs and the website indicated the tasting room should be open. Phone calls and e-mails went unanswered. On a spring evening in 2016, I finally got inside. I was the lone customer, an odd feeling after coming from another downtown brewery where business was buzzing. Melissa Herrera, the bartender, explained that Gibbs was overseas and the brewing team was in transition. I had four unremarkable beers that Herrera said were made by a previous brewer.

In the next months, the business appeared to change direction. Chris Kyle, formerly at James River Brewery, was hired as manager and immediately acknowledged past problems. "The place was run-down, it was dirty, it was missing some type of character," he told *C-Ville Weekly*. "If you don't have the best beer on the block and your place looks like crap, that's a recipe for disaster."

The recipe for disaster recovery has included new beer recipes, a change of staff (including brewer) and a cleanup of the physical facility. The initial reception was positive, but the small brewing capacity (twenty-five gallons per batch) presented limits. Still, "we're the only nanobrewery in Charlottesville," Kyle told me. "We want to be the local pub that makes its own beer."

Pro Re Nata Farm Brewery

When the first taps opened in September 2015, Pro Re Nata Farm Brewery had a lot of growing to do—literally—to earn its agricultural spurs. There were more cars than crops at the location off U.S. 250 outside Crozet, but the brewery's site is zoned agricultural, so the later stages of development are expected to supply hops and whatever else is needed. Actually, Pro Re Nata means just that—"as needed."

"[It] is a Latin term we use in medicine when we write prescriptions for pain medication," co-owner John Schoeb, a dentist, explained in a 2015 interview in the *Crozet Gazette*. "I would write it like this: 'Take one or two Percocet every six hours PRN dental pain.' So it means 'as needed.'"

The initial beers—Claudius Crozet Cream Ale and Old Trail Pale Ale—were brewed at Three Notch'd Brewing Company in Charlottesville. Brad Hulewicz soon was stoking up the seven-barrel Deutsche Beverage system, and the beer menu was fleshed out to offer Beans Deep Coffee Stout, Hop Drone IPA, Doctor's Orders (a German export lager in the Dortmunder style) and other brews.

The emphasis is on drinkability. "John said to give him three kinds of beers that he and his friends would like, and then we could do whatever we want with the rest," Brian Combs, general manager, told me in a 2015 interview.

The Claudius Crozet Cream Ale, named after the engineer and surveyor who is the town's namesake, fits that bill in particular. Like kölsches and some saisons, cream ales serve as a gateway beer for the non-craft drinker and provide thirst-quenching quaffing for geeks. Combs said that with the kölsches already available in the area—Blue Mountain's 151 Kölsch and Champion's Killer Kölsch, to name two—the cream ale made sense. "It's an underutilized style. It was something we could do fast and please the owner. It's gone gangbusters," Combs said.

PRN complements nearby Starr Hill Brewery in making Crozet a destination for beer lovers. The five-thousand-square-foot building once was a Moose Lodge, and a Moose sign that remains has proved popular with area residents, some of them lodge members. The ambience combines a family-friendly game room at the entry with a spacious bar area. The bar itself is topped with copper and paneled with locally milled wood. Outside, a fire pit surrounded by Adirondack-style chairs gives imbibers a view of the Blue Ridge, although Route 250 offers a fairly steady buzz of traffic.

The site includes more than thirteen acres. In addition, Schoeb has twenty acres on his private property where hops already grow, and Combs, a brewer in his own right, has about 150 Cascade and Chinook plants at his home. The plan is to use those hops in PRN ales, although varieties like Amarillo, Centennial and Columbus will be used to beef up the bitterness in Hop Drone IPA (71 International Bitterness Units) and others.

Those hoppy styles are no stranger to Hulewicz, whose brewing background extends to San Diego, and Combs, a fan of hop-centric Stone Brewing Company. "But we don't want to duplicate what's done with the West Coast styles. Brad wants to put his own stamp on that," Combs said.

The production goal for the first year was 2,500 barrels, and help from other breweries has been a boost in reaching that goal. "That's the good thing about the local beer community. Almost everybody wants to help out," Combs said. That's a two-way street, for PRN has jumped in to help with community affairs. In January 2016, it tapped kegs of Kerri's Cure Belgian Pale Ale, a collaboration that involved nineteen other breweries in the state. The beer honored Kerri Rose, wife of Matt Rose and co-founder of Forge Brew Works in Lorton; she had died of stomach cancer the previous September after giving birth to the couple's son.

Hulewicz, a friend of the Roses, echoed Combs in praising the helping hands in the brewing community. "That's one nice thing about the brewing community that I think differs from other industries," he said. Help comes just as the prescription says—as needed.

James River Brewery

Every June, on the Wednesday after Father's Day, a fleet of long, narrow boats pulls up on the banks of the James River in Scottsville. Time takes a holiday as men and women in eighteenth-century garb—floppy hats, flowing skirts, blousy shirts—tie up their bateaux for a breather on a 120-mile journey spanning eight days on what used to be Virginia's busiest highway.

For the reenactors, it's a pit stop—a chance to recharge and refresh. For the town, it's a chance to celebrate its heritage with music, dancing, feasting and drinking, including quaffing beers from the local brewery. "It's our second-biggest day of the year," said Clay Hysell, taproom manager at James River Brewery (Hysell left James River in June 2016 to work at Wood Ridge Farm Brewery). Fourth of July takes the top spot because the town's parade goes right by the brewery's front door. But the bateau pictured on the brewery's logo shows where the owners view their identity.

The beers also evoke the town's association with the river with names like Hatton Ferry American Pale Ale, River Runner ESB, Fluvanna Fluss Hefeweisen and Antwerp Ferry Belgian Pale Ale. The tasting room is a cozy space rich with Virginia white elm and reclaimed wood, and some of the beams date to the building's origin as a tobacco warehouse in antebellum times. It escaped burning when Union troops passed through the area and over the years has served as a factory (making ribbons and epaulets for band uniforms), a furniture store, an antiques store and a car dealership.

Clay Hysell (left), one of the original investors and former taproom manager at James River Brewery, provides Mark Tait with a sample of one of the beers in Scottsville. *Photo by Lee Graves.*

The brewery has gone through a few transitions of its own. The present operation is the third effort to hit the bulls-eye in terms of producing consistently high-quality beer in a market with high standards. "We call it JRB 3.0," said Hysell.

JRB 1.0 was started in September 2012 by Chris Kyle and Dustin Caster, the initial head brewer. Some of the funds came through shares sold to local residents, including Hysell. The original brewing equipment, a one-barrel pilot system with plastic fermenters, was unequal to the task in terms of both volume and consistency.

So the search for a bigger and better setup took the owners to China, where they purchased a twenty-barrel system. Unfortunately, installing it and getting it running proved difficult. Original production plans also seemed slippery, and by January 2014, the shareholders were demanding change, Hysell said.

That group tried to run things for a while, but obstacles—including still being unable to get the twenty-barrel system operational—proved insurmountable, so a core group of the shareholders closed things down and

started afresh. An initial step was calling on two consultants with marquee credibility, John Bryce and Jacque Landry. Bryce was a key figure at Starr Hill Brewery, is active in the Master Brewers Association of the Americas and has started his own hops business, the Lupulin Exchange. Landry was the original brewer at South Street in Charlottesville and now is head brewer at Basic City Brewing Company in Waynesboro. Professional experience, Bryce noted, was a key deficit. "None of them had any experience in the industry so they didn't know what to do."

Landry helped develop recipes and get new brewer Blake Sherman oriented on a 3.5-barrel system until the larger equipment was ready to go. "John and I definitely drilled some fundamentals in while we were there, and I think they're going to be in good shape with that," Landry told me in a 2015 interview. I agree. My personal experience, after drinking James River's beers through the first two iterations, is that the brewery is now on solid ground. At the 2015 Virginia Craft Brewers Cup, the Fluvanna Fluss won gold and Green-Eyed Lady won bronze in their categories.

A collaborative effort with the James River Association has yielded an inviting beer garden that protects the watershed with buffers along Mink Creek, which flows behind the brewery. A second bar, a fire pit and outdoor amenities make it a prime spot for relaxing and listening to the live music in warm weather.

Many of the beers cater to that sunny, just-off-the-river, thirst-quenching mode. The hefeweizen weighs in at just under 5 percent alcohol by volume and invokes its German heritage with Bavarian yeast and Tettnanger hops. The Hatton Ferry American Pale Ale, at 5.6 percent ABV, uses Amarillo and Centennial hops for relatively low bitterness and high drinkability. The brewery doesn't shy away from heftier offerings, though. Green-Eyed Lady Belgian Strong Ale, which is brewed with pistachio nuts, gets some respect with 10 percent ABV.

Like the bateaux that pull up annually, James River Brewery appears to have survived the bumps and scrapes of some early rapids and settled into a smoother course toward its destination—being part of the community, reflecting its heritage and providing flavorful beers. "We want to expose more people to the fact that we're not the old James River Brewery, that we have solid beer with good taste," Hysell said. A crowning achievement came at the 2016 Virginia Brewers Cup, where the brewery's River Runner ESB won Best in Show.

BEYOND THE LOCAL BOUNDARIES: TO THE SOUTH

Beer adventurers don't have far to go outside the Charlottesville-Albemarle-Nelson region to find delicious beers and interesting settings. Richmond has evolved into a beer mecca in its own right, particularly with Stone Brewing Company's facility coming online in 2016. But let's look at points west and south that don't get quite as much attention and make for easy day trips.

Loose Shoe Brewing Company

Husband-and-wife teams form the backbone of several outliers, including Loose Shoe Brewing Company in Amherst County's Ambriar Plaza. Derin and Kitty Foor opened the doors on the tasting room for their one-barrel brewery in April 2015 and immediately were embraced by the community, as well as travelers seeking a pit stop between Nelson County and Lynchburg.

The tasting room reflects a shared passion: horses. Derin worked for seventeen years as a farrier before opening the brewery, and Kitty was a

Derin and Kitty Foor operate Loose Shoe Brewing Company in Amherst County's Ambriar Plaza. *Photo by Lee Graves.*

longtime horse enthusiast before back surgery prevented her from riding. Various types of horseshoes are imbedded in barley malt under a glass countertop at the bar. A large painting with a stallion and their logo dominates one wall.

Derin, who came to Amherst in 1992 from York, Pennsylvania, began homebrewing six years before taking the leap into his own brewery. "I started homebrewing because I was searching for better beer," he said. He found help at Pints O' Plenty in Forest (more on that operation in a minute). His first batch was a Belgian tripel that won a competition sponsored by the local homebrewing club, and he was hooked.

A lean, leathery man accustomed to working in the elements, Derin turned to professional brewing after coming to terms with the physical demands of his job. "I'm not going to be shoeing horses forever," he said. Kitty, a nurse, tends to the business side of things and helps with research and development. They rotate among about thirty-six recipes, keeping six beers on tap, and their most popular beers have been a Vienna lager, a kölsch and an Irish stout. Derin's love of cooking fuels an adventurous palate. He wants "to use ingredients that are not traditional and brew beers that are not to style."

The Ambriar Imperial Pale Ale is an example. Derin uses five hop varieties—Horizon, Magnum, Nugget, Chinook and Citra—in the boil and then dry-hops with Magnum, Chinook and Citra for an intense aroma. Loose Shoe's diversity shines with brews such as Haulin' Oats Oatmeal Stout, Hot Shoe Jalapeño IPA and Black Stallion Saison.

Apocalypse Ale Works

Like Loose Shoe, Apocalypse Ale Works in the Forest area of Bedford County is the product of a husband-and-wife team that got its start through homebrewing. Doug John had established his reputation for skill with the brew pot by winning a national award that allowed him to brew on professional equipment at Heavy Seas brewery. His Pints O' Plenty shop became a destination for other hobbyists seeking ingredients and lessons from John.

And like many others, John's passion for homebrewing led to an itch he could scratch only by going professional. Virginia law, however, prevented the same person from operating both a retail shop and a brewery, so Lee, his wife, was designated head of Apocalypse Ale Works when the business was created in 2013.

The Johns have defined roles. He does the recipes, she does the tasting room and both brew. "He's my unpaid technical assistant," Lee quipped when I interviewed the Johns shortly after they opened Apocalypse. "It was a dream I forced upon Lee," Doug said wryly.

Their thirty-barrel system is located in a former firehouse next to Pints O' Plenty, all within a few miles of Thomas Jefferson's historic retreat, Poplar Forest. Outside the brewery, stairs climb to a furnished deck and the tasting room. Banners display the beers' bold artwork—the Cenful Blonde, a Belgian-style golden ale made with ginger; Winter Snack, a holiday imperial stout with flavors of raisins, orange peel and cinnamon; and Lustful Maiden, a Belgian Dubbel with notes of toffee and roasted almonds. Outside, picnic tables invite patrons to relax, socialize and play games next to a hops garden.

Investing time and money into making beer required a leap of faith. Both left regular salaried jobs—he in manufacturing, she as a dental hygienist. Hence the brewery's name. "Apocalypse means the end for a new beginning," Lee said. "Now we're able to do something that makes us happy.…The pleasure that I get from seeing people's faces the first time they take a sip of our beer—it's a huge payoff."

They've also received ample recognition for the quality of their beers, beginning in 2013 with Lustful Maiden winning gold at the U.S. Open Beer Championship and silver at the Virginia Craft Brewers Cup (Sixth Seal Chocolate Stout also won gold there). More medals have followed, including silver for Heavy Red Horseman Scottish-style Ale at the 2014 World Beer Cup.

Beyond the Local Boundaries: To the West

These five breweries are part of the Shenandoah Beerwerks Trail.

Seven Arrows Brewing Company

Aaron Allen believes in the basics. The four traditional ingredients of beer—water, grain, hops and yeast—provide plenty of options for flavorful brews. "My thing is that I try to be true to style when I'm making beer," said Allen, co-owner and head brewer at Seven Arrows. "I'm not interested in the crazy, everything-under-the-sun, throw-it-in beer. You can create a huge range of flavors just through your malts and hops."

One of several husband-and-wife teams in Virginia, Aaron and Melissa Allen operate Seven Arrows Brewing Company outside Waynesboro. *Photo by Lee Graves.*

For proof, check out Allen's Hermenator Doppelbock, a richly malted lager; the Sleeping Bear Weizenbock, where the 7.1 percent ABV will make you want to curl up for a long winter's nap; and the smoked beer. "People actually thought there was bacon in that," said co-founder Melissa Allen, Aaron's wife.

Seven Arrows is tucked in a nook off U.S. 250 between Waynesboro and Staunton. It's also just over Afton Mountain from the burgeoning beer scene in the Greater Charlottesville region. The Allens saw the growth of Blue Mountain, Starr Hill, Devils Backbone, Wild Wolf and other breweries and decided that the time was right to fulfill their ambition. After a long hunt for the right location, they opened the doors on their tasting room—and opened their twelve taps—on New Year's Eve 2014–15.

Aaron, an Illinois native, began homebrewing while a student at Michigan State University, where he studied chemical engineering. He met Melissa while living in Indiana—she was a student at Indiana State at the time but got her degree from Florida State. A job at MillerCoors whetted his appetite for professional brewing, and he took courses through the Institute

of Brewing and Distilling. Melissa, a software engineer, studied at James Madison University to earn a master's degree in business administration, primarily to take care of the business side of their enterprise.

Their flagship beer is Skyline Lager, an easy-drinking entry (4.5 percent ABV, twelve IBUs) that won a gold medal in the 2015 Virginia Craft Brewers Cup competition. Other core beers include Eventide IPA, a mildly bitter brew at sixty-five IBUs; Sinistral Wheat; Aurora Pils; and Boreal Amber. You're likely to find a porter, milk stout and two saison interpretations in the rotation. Down the line, look for barrel-aged beers and sours.

Amid the charming downtown area of Staunton, where thriving businesses inhabit historic buildings, you'll find two breweries within easy walking distance and a third a quick car ride away.

Shenandoah Valley Brewing Company

Starting a homebrew supply store in 2012 in a late 1800s building that once served as a grain warehouse, Mary and Mike "Chappy" Chapple later opened a small tasting room facing the train depot and then expanded as the beers found favor in the local market. The tasting room features cream-colored walls with kelly-green bricks and accents, a wooden bar and an assortment of old-time tools.

The philosophy is simple: "Beer for the People." "We want people to be able to come in and relax and enjoy themselves. We want to create a family atmosphere," Mary Chapple said while tending the taps on a Saturday afternoon in February 2016. She handles the marketing and financial side of the operation, while her husband manages brewing on the 1.5-barrel system (although Mary developed the recipe for a West Coast–style IPA that was set for release in the spring of 2016).

Their most popular offering is First Brigade Red IPA, a sixty-IBU amber ale with a bready, toffee underpinning of malts to support the hops; a nice dry finish makes this a treat. The Long Meadow Kölsch and Valley Pike Prohibition serve as gateway beers for drinkers new to the craft market. "Our clientele is all over the map. Some people come in and just want a Budweiser clone," Mary said. "We made an apple ale that sold out in three weeks."

Virginia Native Amber Ale holds a special place among the seventeen to twenty beers on tap. "[It is] brewed entirely with malt and hops that are grown and processed in Virginia," the beer menu proclaims.

Redbeard Brewing Company

While Shenandoah Valley Brewing targets families, Redbeard is more a place to meet your buddies and talk about the greatest save ever in ice hockey or the most awesome mountain bikes or the best trails to hike in the Blue Ridge.

A row of barrels in the window facing Lewis Street complements brewer/owner Jonathan Wright's theme of "Small Batches of Big Beers." Flights come in small glass containers that resemble mini-Mason jars, and the offerings include fruity creations—a hugely aromatic Blueberry Wheat Ale (5 percent ABV and forty IBUs) and a subtle Peach Saison (5.5 percent ABV and twenty IBUs)—as well as heftier brews such as the unfiltered Best Coast IPA (7.5 percent ABV and sixty-five IBUs).

Redbeard is the older of the two downtown breweries, releasing its first batch—the flagship America's Pale Ale (5.5 percent ABV and fifty IBUs)—in 2010. Another pale ale, the Pennyroyal, won a gold medal in the 2015 Virginia Craft Brewers Cup competition.

As with Shenandoah Valley and other breweries, Redbeard makes the most of the area's agriculture. Its 2015 Harvest Ale was brewed with more than fifteen pounds of wet Cascade hops from Whipple Creek Farms in Rockbridge County.

Queen City Brewing

For folks who want to brew their own beer, Queen City on Springhill Road offers more than eighty recipes and equipment for fifteen-gallon batches. Or you can schedule a Saturday "brewers apprentice" session to see how the pro does it on the in-house 6.5-barrel system.

Queen City, founded by brewer Greg Ridenour, traces its roots to 2003 and touts being Staunton's first brewery since Prohibition. I had a "duh" moment when I asked Luke Edmondson, the man behind the bar, why so many beers had rabbit names—Smitten Rabbit, Retro Rabbit, King Rabbit, Jackelope, Apricot White Rabbit and so on. "Hops," he said. I banged my head against the bar.

Stable Craft Brewing

Like Loose Shoe, an equine theme identifies Stable Craft, except this operation is located on a horse farm north of Waynesboro. Ten active horse stalls were remodeled for the tasting room, where beers using hops grown on the farm are available from the sixteen taps. The brews range from an easy-drinking American Blonde at 3.9 percent ABV to a roasty 6.6 percent ABV American Stout with chocolate notes and hop bite (check out the Fuggle flavor).

In the Works

Here's a look at some breweries in the region that were planning to open in 2016.

Wood Ridge Farm Brewery

Take a family farm dating to the 1800s and spanning some three hundred acres, marry that with a passion for brewing and then throw in a healthy dose of do-it-yourself old-school self-sufficiency, and you get an idea of the motivation for Barry Wood and his brewery.

Wood grows and malts five varieties of six-row and two-row barley—plus two strains of wheat—on his property off U.S. 29 south of Charlottesville. The Wood's Mill Malt House operation, under the supervision of Cory Hall, preceded the commercial brewing and construction of the tasting room. The latter features fragrant cedar posts and beams cut and planed by Wood; the bar, cut from a single cedar tree, is a sight and smell to behold. Brewing will take place on a seven-barrel system.

Wood's vision has been to create beers where every ingredient—grain, hops, water and even the yeast—was sourced from the property. That will take time, as hops require years and intense labor to mature, plus early samples of yeast taken on the property didn't suit the styles of beer Wood wants to brew. That said, the sense of place he has created eclipses any quibbles about terroir.

Wood has supplied malt to various distilleries as well as breweries. In terms of his own beverage choices, "I don't drink liquor, so I turned to beer."

Random Row Brewing Company

Being family-friendly will be a priority for Random Row when the 3,700-square-foot brewery opens in the former Moxie Hair and Beauty Lounge building off Preston Avenue in Charlottesville. Games for children, space for strollers, picnic tables and a beer garden factor into an ambience geared toward multiple generations.

Much of that comes from the fact that the founders—Bradley Kipp, Kevin McElroy and Bob Thiele—as well as general manager Matt Monson, all have families of their own. "We want to create a space that people can come to and enjoy the space, not just the beer," McElroy said.

The beers will be brewed on a ten-barrel system using a seven-barrel fermenter; production will be focused on in-house sales initially with a target of up to five hundred barrels per year. McElroy, who will be head brewer, and Monson, who will manage the tasting room, are experienced homebrewers, and they envision a six-beer menu for starters with an IPA using Falconer's Flight hops and a German fest lager included in the lineup.

Like Starr Hill, the name refers to a historic neighborhood of Charlottesville, in what is now Vinegar Hill.

Basic City Brewing Company

Here again, history plays a role in the birth of a brewery. This section of present-day Waynesboro was a railroad and industrial center that served as home of the Basic City Mining, Manufacturing and Land Company, incorporated in 1890. The two cities merged in 1924; voters rejected using a hyphenated name for the locality, so Basic City faded into memory.

That was the case until Bart Lanman and his brother, Chris, pooled the resources of twenty-seven investors and began transforming the former Virginia Metalcrafters site into a brewery. It took a visionary's eye to look beyond the shattered glass windows, puddles on the concrete floor and bone-chilling cold in the building to pursue their goal. "I'd driven by this thing a thousand times. I knew the building needed a lot of work, but this is a really cool spot," Bart Lanman said in early 2016 as we stood in what would be Basic City's tasting room.

With veteran Jacque Landry as head brewer, Basic City will occupy sixteen thousand square feet and employ a twenty-barrel system that will be visible

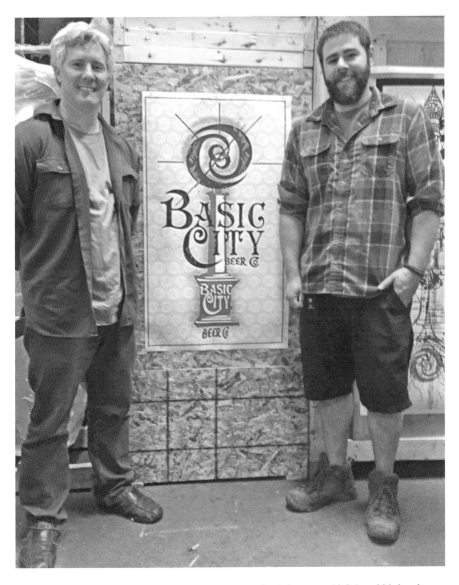

Jacque Landry (left) will head up the brewing, while Chris Lanman (right) and his brother, Bart, will guide the business operation at Basic City Brewing Company in Waynesboro. *Photo by Lee Graves.*

beyond glass windows in the tasting room. The Lanmans and Landry started testing recipes in 2015 on a one-barrel system in a garage. "That's so we can say that we started in a garage," Bart Lanman said.

Hardywood Park Craft Brewery

A stalwart of the craft beer scene in Richmond, Hardywood Park announced in April 2016 its plans for a brewery, taproom and beer garden on West Main Street in Charlottesville.

Known for such brews as its easy-drinking Belgian-style Singel, its Great Return IPA and its hugely popular Gingerbread Stout, Hardywood targeted the Uncommon Building at 1000 West Main for a 3.5-barrel brewery and a 1,100-square-foot taproom to open in September 2016. "The brew house is five times the size of our current pilot system" in Richmond, said co-founder and brew master Patrick Murtaugh in a news release. "It will give us the opportunity to pursue more collaborative brewing efforts and to experiment with innovative recipes in a dedicated facility." Plans included having twelve taps of Hardywood beer on draft, live music and light fare. The project was anticipated to cost $300,000.

The Charlottesville venture came eight months after Hardywood announced plans for a sixty-barrel brewing and packaging facility on twenty-four acres in the West Creek Business Park in Goochland County. That $28 million endeavor includes an amphitheater for live music, beer garden, taproom and walking trails.

Chapter 9

HOPS AND HOMEBREWING GROUPS THRIVE

On a chilly, blustery day in February 2014, more than 125 people gathered at the Rockfish Community Center in Nelson County for a daylong workshop on growing hops. The meeting included curious hobbyists, veteran growers, commercial brewers and a small group of scientists sharing knowledge about an agricultural product sprouting new shoots from native roots.

As Stan Driver describes it, that workshop was a seminal moment in the area's nascent hops scene. "We had a lot of the players all in the same room. It was a point we all began communicating regionally, and Virginia Tech really got on board. They said, 'Oh, there's a demand for us to do something here,'" he said.

Driver is commonly regarded as the godfather of the hops-growing movement in Virginia. He started in the late 1990s while "dabbling" with homebrewing and running a retail nursery in Nelson County. He grew Cascade plants in potting containers and gave away bines and rhizomes to local homebrewers.

Things went from a backyard interest to a commercial possibility when he saw the pioneering efforts at Blue Mountain Brewery in Afton. Driver's Cascade plants were flourishing; Blue Mountain's were failing. "Taylor and Mandi [Smack] came and asked me if I could replant their hop yard, so I began to work on that in the fall of 2009. I replanted it all," Driver said. "I'm not aware of anybody who was doing it on a commercial scale, at least publically."

Stan Driver tends to Cascade hops growing at Blue Mountain Barrel House in Arrington. *Photo by Lee Graves.*

That quickly changed. The booming craft beer movement fed interest in every aspect of making beer. Farm breweries such as Lickinghole Creek Craft Brewery in Goochland County grew hops successfully, and enthusiasts with sufficient acreage followed in the footsteps of Driver and his Hoot 'n' Holler Hops business.

In 2013, momentum was sufficient to motivate Driver to form the Old Dominion Hops Cooperative. That group expanded to include growers in Maryland and North Carolina. The interest that fueled that one-day workshop in Nelson County blossomed into events such as the weekend-long South Atlantic Hops Conference, held in Richmond in March 2016. Research by Ken Hurley at Virginia Tech, Laura Siegle of the Virginia Cooperative Extension program, Jeanine Davis at North Carolina State University and others is now contributing to the success of a plant that requires intensive manual labor and is all too subject to disease and fickle growing conditions.

That said, hops are native to Virginia, and as detailed elsewhere in this book, records of cultivation by enslaved workers and farmers date to the

1700s. *Humulus lupus*, a member of the Cannabis clan, was named by Pliny the Elder (or so the story goes); the initial scientific description, however, is attributed to Hildegard von Bingen, a twelfth-century German abbess. Hops provide beer's bitterness as a balance to the sweetness of malt. And as the craft beer palate has moved increasingly to hoppy beers, more craft beer lovers are getting into the hops-growing business.

One of those is Chris Gordon, a Pennsylvania native who partnered with Gordon Giuliano in 2013 to start Charlottesville Hops in western Albemarle County. Their initial effort was 350 Cascade plants on one-third of an acre, yielding twelve pounds of wet hops. Hops take two or three years to mature, and their second harvest totaled eighty-one pounds.

Those hops—and others from nine area growers—went into a specialty beer called Ten Farmers Ale, brewed at Three Notch'd Brewing Company. The 2015 batch used about four hundred pounds of "wet" hops—hops that are freshly harvested without being dried and pelletized. Chris Gordon and I sat in the Three Notch'd tasting room drinking that beer as we talked, and I must admit it was pretty cool to be tasting the fruits of his labor so directly. "It's a beer with our hops in it. It's a delicious beer," Gordon said with pride.

Other Charlottesville-area breweries feature locally grown hops in specialty beers, but using them in a flagship beer raises questions of cost, consistent quality, reliable harvests and dependable deliveries. Pelletized hops are the industry standard, and brewers generally contract years ahead with hop suppliers for precise amounts of specific varieties.

To give brewers some flexibility in that regard, John Bryce founded the Lupulin Exchange. A veteran of Starr Hill and Old Dominion breweries and a member of the Master Brewers Association of the Americas, Bryce noticed a dramatic change in the way hops are bought and sold. The "spot market," where you could buy hops on short notice with no contract, dominated until a hop scarcity in the late 2000s.

"The whole industry in a period of two years went from over 80 percent spot market to less than 5 percent spot market, which meant that every brewer in the country started contracting for their hops," Bryce said. That enhanced stability but hampered flexibility. So, in December 2014, he started the Lupulin Exchange, sort of a "New York Stock Exchange for hops." It hit $1 million in sales in the first ten months and has been well received in the industry, Bryce said.

Growers in the Charlottesville region do have a presence in that exchange, but it's small compared with hops hot spots like the Pacific Northwest. In Washington State's Yakima Valley, for example, a grower can expect ten thousand pounds of

wet hops per acre, Driver said. In the Piedmont, two thousand pounds per acre is an achievable goal. Higher volume means lower prices, plus quality is more consistent on established farms. "Some people have some very high hopes for hops in this area, and I think it's a little optimistic," Bryce said. "You've got a lot of obstacles against it."

Some of those obstacles are a shorter growing day here; a hot, humid climate; and susceptibility to downy mildew and other diseases. Cascade hops fare the best, Driver said, although growers are experimenting with Zeus, Nugget, Cashmere, Sorachi Ace and other varieties.

Driver sees the groundswell of growers spurring research, agritourism and creative beers by craft brewers. But he preaches caution against unrealistic expectations. Most people don't realize the physical labor involved in setting up a hops yard, keeping the plants healthy and harvesting the cones. The balance to that, as Gordon sees it, is growers helping growers. "It's a great community of people, for sure. Everyone wants everyone else to succeed."

The ultimate challenge, Driver said, is to discover or hybridize a hop that grows well and is unique, creating a niche in the market nobody else would have. "That would be the magic bullet for our hop industry."

CAMRA

When Jane Jefferson was brewing beer at Shadwell back in the 1700s, the ales of British tradition served as her point of reference. She might not have had the same barley and hops at her disposal, but her taste buds were calibrated to measure quality by English standards.

So it should come as no surprise that Charlottesville's main homebrewing club takes its inspiration from the United Kingdom. CAMRA (Charlottesville Area Masters of Real Ale) was named for a British organization with the same acronym. In England, CAMRA stands for the Campaign for Real Ale; "real ale" is traditionally brewed beer that's allowed to condition, or finish fermenting, in a cask.

The passion for brewing flavorful beer transcends one nation, and it's been a bond for many a homebrewer. Such was the case with the CAMRA club's three founders: Jamey Barlow, Christopher Welte and Tom Wallace. I sat with them at Charlottesville's Court Square Tavern in August 2015, dimpled pub glasses brimming with beer arriving like images to illustrate their story.

From left: Tom Wallace, Christopher Welte and Jamey Barlow toast the camaraderie they have maintained through founding and sustaining CAMRA. *Photo by Lee Graves.*

Barlow and Welte were co-workers at Crutchfield when they invited Wallace to join them for a discussion at South Street Brewery in 2007. "We sat down and we talked about how we all liked to brew, but there was no venue to get together and talk about it," Wallace said.

Welte had joined a homebrew club in Ohio before moving to Charlottesville. He was dismayed at the paucity of places to buy supplies and the lack of a local organization. "I missed that camaraderie, so when Jamey said, 'Hey, let's go meet with a friend of mine and talk about something,' I thought, 'This is going to be great.'"

They developed bylaws, put out fliers, spread the word by mouth and eventually developed a website. Attendance at the initial meeting—at Court Square Tavern in November 2007—exceeded expectations. The only trouble was they couldn't bring their homebrewed beer to share, so they eventually searched for another location. "We knew we would die if we didn't move," Wallace said.

They found a new home in 2010 at Timberwood Grill, off U.S. 29 north of Charlottesville. The spot wasn't far from one of the early homebrewing

supply stores in the area. Fermentation Trap had opened in 2008 and added a small half-barrel brewery, Beer Hound, before owner Kenny Thacker closed that location and reopened Beer Hound in downtown Culpeper in 2014.

CAMRA now has roughly fifty members, and attendance hovers between twenty-five and thirty-five at meetings (on the second Tuesday of the month). A key priority is education. Veteran brewers share tips with neophytes, and meetings include presentations that run the gamut from off-flavor tastings to demonstrations of assembling brewing equipment. Club competitions have rewarded winners by having their recipes brewed on local commercial systems.

Other aspects of the club reflect the founders' interests. Welte loves focusing on traditional styles and brewing them precisely to specifications. Barlow enjoys the creative, adventurous aspect (he won a gold medal in the 2016 American Homebrewers Association's National Homebrew Competition for an American sour aged in an oak barrel). "I've never brewed the same beer twice," Barlow said. Wallace underscores the social outlet of gathering to discuss and sample beers.

The camaraderie among the three also is obvious as they joke and share tales over ESBs and Oktoberfests. "We are three parts of a triangle, and we all still get along," Welte said, and the three clinked glasses.

"Beer is the stuff that brings us together," Barlow added.

BREW BETTIES

Anne Deery was listening to a group of women talking about craft beer when the thought popped into her mind: "Those are girls I'd like to hang out with." So, Deery, a native of North Carolina who is familiar with Asheville's beer scene, started wheels turning in 2013 to organize Charlottesville's Brew Betties. The meet-up group is now about sixty members strong and gathers roughly twice a month.

Topics range from homebrewing—one of Deery's passions—to education. At one meeting, the Betties brought beers from their hometowns to pass around and sample. At another, they met at a Charlottesville brewery to pair different beers with Girl Scout cookies. In the spring of 2016, the members met at Three Notch'd Brewing Company for a group brew, and the resulting Maibock was tapped on April 21 for public consumption, with a portion of the proceeds going to charity.

Members of Charlottesville's Brew Betties join head brewer Dave Warwick at Three Notch'd Brewing Company to celebrate the release of their Maibock. *Photo by Lee Graves.*

Seamane Flanagan, one of the Betties, and her husband, Rob Gowen, won the 2014 local Homebrew for Hunger competition with their toasted coconut porter.

FIFTH SEASON

Finding homebrewing supplies in Charlottesville was a bit of a challenge at one time, but Fifth Season Gardening Company on Preston Avenue has worked to address that. "Central Virginia is really big on the homebrewing scene now," said store manager Morgan Mott. "We have homebrewers come in every day."

The Charlottesville location is the fifth in a group based in North Carolina. All of the local employees are homebrewers, Mott said. She had just finished brewing a whiskey barrel stout, and she can share mistakes as well as triumphs with customers. How-to books by Charlie Papazian and

Store manager Morgan Mott oversees the hops and other homebrewing supplies at Fifth Season Gardening Company. *Photo by Lee Graves.*

John Palmer line shelves beside rows of containers filled with various malts; hops, yeast and brewing equipment also are readily available.

The store, which grew out of hydroponics and do-it-yourself interests in general, caters to wine, mead and cider makers as well as beer buffs. Assistant manager John Jones estimated that supplies for all of the fermented beverages constitute 20 to 30 percent of the store's sales, with beer accounting for about 90 percent of that. "We have a lot of people who have been brewing for years and years come in for supplies; and then there are people who are just coming out of UVA and been drinking the craft beers here, and they ask 'Where do I start?'" Mott said. "We also see a lot of people in between as well. We definitely get to see people grow."

Chapter 10

MONTICELLO'S LEGACIES

Telling the story of beer and brewing at Monticello has been an ongoing effort over the years, but two major boosts in recent decades have helped put things in perspective.

In 2001, the Thomas Jefferson Foundation received $40,000 to restore the beer cellar in the basement. Half of the amount came from Anheuser-Busch and the other half from John and Bobbi Nau, a Houston couple and longtime contributors to Monticello. John Nau III, a graduate of UVA, has served as president and CEO of Silver Eagle Distributors, the nation's largest distributor of Anheuser-Busch InBev products.

Attention to the beer cellar came as part of a larger effort to restore the dependencies, a job largely under the supervision of Justin Sarafin, assistant curator at the time. Over pints of local beers, he told me about the importance of conveying the complexities of life at Monticello. "You can fill out a three-dimensional picture" with the rich resources—the records of Jefferson and others—and the archaeological work, he said. In particular, reflecting the lives of slaves, their families, the body of their work as a community and the multiple skills of various individuals was important. "Slavery at Monticello was a very particular thing, particular to Monticello."

Peter Hemings stands as an example. His family included Sally Hemings, Jefferson's concubine and Martha Jefferson's half sister, as well as James Hemings, who accompanied Jefferson to Paris during his years as minister to France. Peter was skilled as a tailor, a chef (he learned French cooking techniques from his brother James) and, as noted earlier, a brewer.

The display in the beer cellar at Monticello is part of a larger effort to restore dependencies and reflect the complexities of life there. *Photo by Lee Graves.*

So it is that the beer cellar at Monticello pays tribute to Peter and his training at the hands of Captain Joseph Miller, a professional brewer (see chapter 4). The display explains the basic steps of brewing—malting, mashing, brewing and fermentation—and presents artifacts such as a spigot and a piece of stoneware bottle from the period. Along one wall rests a set of wooden casks, which held the beer as it fermented. Research into that element alone was complex, Sarafin said, because a hogshead of ale differed in volume from a hogshead of wine (Martha Jefferson recorded brewing fifteen-gallon batches in casks; the average homebrewer today brews five-gallon batches).

Also on display are corks and bottles, where the beer was stored until ready for drinking. Bottles were so dear that Jefferson had some wine shipped in

bottles rather than casks to ensure a ready supply of bottles for beer and cider. A reminder: beer and cider were considered "table liquors"—low-alcohol, everyday drinks available before and during the meal. They were not quite of the same status as the wines Jefferson treasured.

The question that automatically pops into the mind of the curious beerophile is this: What did Jefferson's beer taste like? That is virtually impossible to answer because he kept no recipes. An educated guess, however, can be found in Monticello Reserve Ale, a unique collaboration between the Thomas Jefferson Foundation and Starr Hill Brewery in Crozet.

Sarafin worked with Mark Thompson, co-founder and former brew master of Starr Hill, on that project, which began in 2003, well before the initial bottles were released in 2011. They consulted the same book Jefferson

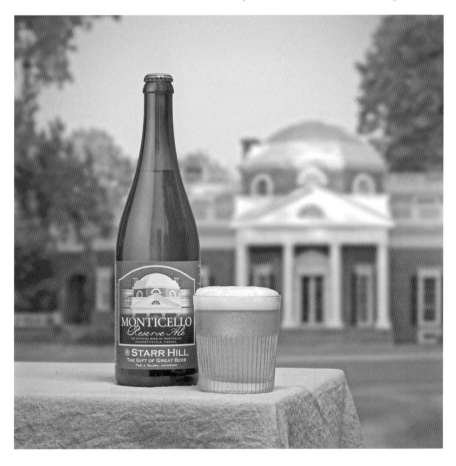

Historical aspects of Thomas Jefferson's brewing guided researchers at Monticello and brewers at Starr Hill in creating Monticello Reserve Ale. *Courtesy of Starr Hill.*

used, Michael Combrune's *The Theory and Practice of Brewing*. They also knew that some barley (traditionally the go-to grain for brewing) was available, but harvest records and other sources indicated that corn and wheat were grown in greater quantity on the plantation and were more prevalent in the brewing. In addition, Jefferson and some of the slaves grew hops there, but the variety and the characteristics are mysteries.

Hops are still grown at Monticello, and Levi Duncan, lead brewer at Starr Hill at the time, recalled smelling and tasting them before using them in the brew. The aroma was negligible, he said, and the cones were very small. "But I think everybody was glad to have some Monticello hops in the beer."

Brewing without barley was "a challenge in its own," Duncan said. (For one thing, wheat yields fewer enzymes to convert starch to sugar; plus, it can be a gummy mess.) Pilot batches led to sample tastings, where the characteristics of the ale were discussed. What evolved was a light-flavored, easy-drinking, unfiltered wheat beer lightly hopped with East Kent Goldings hops (5.5 percent alcohol by volume, twenty-seven IBUs). The use of corn adds sweetness to the profile without dominating. Crowned as the official beer of Monticello, the Reserve Ale won a silver medal in 2011, its first year of existence, at the Great American Beer Festival in the indigenous beer category. "This has been a labor of love," Thompson said when the beer debuted. "I'm thrilled to get the story of Jefferson and beer out."

Sarafin was equally thrilled. "This was a fun project and a neat way to bring something tangible forward to experience that historical setting," he said. "We were on the forefront of pairing research with modern craft brewing on this artifact."

Yet one more tribute to Jefferson's brewing can be found on contemporary shelves. Yards Brewing Company of Philadelphia, which was like a second home to many of the Founding Fathers, brews Thomas Jefferson's Tavern Ale as part of its Ales of the Revolution series. The label is a tad misleading, saying the beer is "based on Jefferson's original recipe." But the intent is not misdirected; brew master Tom Kehoe "worked closely with Philadelphia's historic City Tavern to recreate this recipe," the Yards website notes. Honey, rye and wheat, as well as pale barley malt, go into the brew, which is categorized as a strong golden ale (alcohol by volume is 8 percent). "They made them strong back then to hide their mistakes," Kehoe told the *Washington Post*.

Chapter II

LOOKING AROUND THE STATE

V irginia is for beer lovers, folks."
Governor Terry McAuliffe made that proclamation in March 2016 during the official announcement that Deschutes Brewery of Oregon had selected Roanoke, Virginia, as the site for its East Coast production facility. He would echo that refrain two months later in releasing news that Ballast Point Brewing and Spirits of San Diego would develop a $48 million facility in Botetourt County.

Those developments followed on the heels of two other major West Coast breweries—Green Flash and Stone, both also of San Diego—building plants in Virginia. And those would not have been possible without the already-considerable groundswell of smaller craft breweries that have put Virginia on the map since 2012. That's the year the state's legislature passed a measure commonly referred to as Senate Bill 604. It allowed retail sales of beer and sampling on brewery premises; previously, food had to be part of the equation. A companion piece of legislation that year also enabled manufacturers to lease space in their brew houses to smaller brewers.

Those laws, plus a later measure concerning farm breweries, changed the beer landscape in Virginia. From 42 breweries operating in 2012, the number jumped to 61 in 2013; the pace quickened further, vaulting to more than 140 licensed breweries in the state in early 2016. Virginia and three other states in the South—North Carolina, Florida and Texas—added more than 20 breweries in 2015, making the region one of the fastest-growing in the country, according to the Brewers Association in Colorado.

Beer lovers gather for a festival at Poplar Forest, Thomas Jefferson's retreat in Bedford County. *Photo by Lee Graves.*

Impressive? Certainly. But consider this: The breweries along the Brew Ridge Trail—South Street, Starr Hill, Blue Mountain, Wild Wolf, Devils Backbone—were in business before the game-changing laws. Only one existing Virginia brewery, Legend in Richmond, predates Starr Hill, and don't forget that Blue Ridge brewpub on West Main Street was the first of its kind in the state. So it might be safely said that the pioneering spirit in brewing kindled by Thomas Jefferson still burns in the region.

Indeed, numerous other localities have followed this region's lead and created trails that showcase not only breweries but also agriculture, history and craft beverages in general. From Loudoun County to Tidewater, from Richmond to Harrisonburg—maps and websites have been created to link frothy destinations. The Virginia Tourism Corporation even has its own beer map, paired with event listings and news tidbits.

"I Had This, I Did This"

"We see the entire culinary environment as one that's extremely attractive to travelers," Rita McClenny, president and CEO of the Virginia Tourism Corporation, told me in a 2014 interview. "People are looking for unique experiences. When they go to a destination, they can come home with a fantastic story of 'I had this, I did this.'"

While there's plenty of love to go around in Virginia, not every locality welcomes breweries with open arms. Deschutes's road to Roanoke involved a prickly pit stop in Albemarle County. In 2015, the Oregon brewery used back channels to express interest in land just south of the Charlottesville limits. A proposed amendment to Albemarle's comprehensive plan would have designated 85 acres for light industrial use and 138 acres for parks and greenways. The Planning Commission rejected the idea, and on an unseasonably hot evening in September, roughly one hundred people packed into the county supervisors' meeting room to speak on the issue. Many residents expressed concerns about increased truck traffic and jeopardizing the semirural character of the county. Others, including at least one local brewer, pointed instead to more jobs and increased revenue. The supervisors eventually approved an alternative plan that was significantly scaled down, and Deschutes looked elsewhere.

Roanokers created a far more hospitable climate, including a social media campaign, grants and other economic incentives, and Deschutes was hooked. Construction on the $85 million plant is expected to begin in 2019. In the meantime, the Stone Brewing Company facility in east Richmond—a 200,000-square-foot facility involving 288 jobs and an initial capacity of 100,000 barrels—opened its tasting room in February 2016 and started brewing beer locally in early June. Green Flash also was poised that fall to open its production plant—a 100,000-barrel system in a 58,000-square-foot space on General Booth Boulevard in Virginia Beach.

How do these big breweries affect Virginia's smaller operations, where the theme of "local, local, local" is a resounding chorus? At this writing (June 2016), it's too early to tell. Some brewers question the packages of grants and other incentives offered to the larger breweries, citing the lack of similar support by localities in their areas. One Charlottesville brewer said that the reason Stone picked Richmond is because "Virginia is weak."

The great majority of brewers, brewery owners and craft beer fans, however, appear to applaud these developments. Hunter Smith, owner of Champion Brewing Company in Charlottesville, spoke in favor of

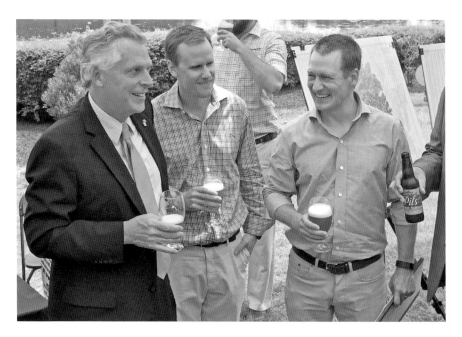

Virginia governor Terry McAuliffe (left) joins Hardywood Park Craft Brewery co-founders Patrick Murtaugh and Eric McKay (right) at the ceremony announcing the brewery's new Goochland County facility. *Photo by Lee Graves.*

Deschutes's Albemarle plan, and many others have noted that Virginia has gained prominence as a beer destination thanks to the combination of these national brands and local flavor.

One measure of health is expansion of existing breweries. Two notable Richmond breweries—Hardywood Park and Triple Crossing—announced plans for new facilities in 2015 and 2016. Brass Cannon in Toano laid the groundwork to move to a bigger space outside Williamsburg. Other stories echo across the Old Dominion.

Quality of operations is another measure. Before being acquired by Anheuser-Busch InBev and losing its "craft brewery" status, Devils Backbone won successive national awards at the Great American Beer Festival in the small brewpub and small brewing company categories; then, in 2014, it was named Mid-Size Brewing Company and Mid-Size Brewing Team of the Year. In 2015, Port City Brewing Company in Alexandria was named Small Brewing Company and Small Brewing Company Brewer of the Year at the GABF.

"Being named small brewery of the year is an unbelievable recognition," Port City owner Bill Butcher told the *Washington Post.* That also means that

four years in a row, from 2012 to 2015, a Virginia brewery was named the best in the nation in its category.

Hop farms are proliferating, stimulating research at universities in the mid-Atlantic region. Farmers are experimenting with barley production and malting, and they're developing relationships with brewpubs for fresh meat and produce. Urban breweries provide active markets for food trucks, neighborhood bakeries and local coffee roasters. Families target tasting rooms and beer gardens as destinations for relaxation, recreation, socialization, entertainment, family time and learning.

Diversity of Beer Styles

Unlike the first swell of microbreweries that crested in the 1990s, the current scenario seems more mature and sustainable, although the pace of growth, in terms of volume, decelerated nationally from 18 percent in 2014 to 13 percent in 2015. Entrants now recognize that smart business plans, savvy marketing, consistently excellent quality and measured growth are key to survival. While competition for shelf space and tap handles is lively for breweries that choose to pursue ambitious distribution, the landscape looks ripe for small operations content to share their passion for great beer with the local gang and curious visitors. Success depends on creating unique and attractive identities through beers, location, staff and ambience. The growing sophistication of the beer drinker will demand as much, and times are proving that the craft boom is a cultural shift, not a novelty or fad.

What is equally notable is the diversity of offerings in the brewing landscape. Traditional styles (stouts, porters, pilsners, pale ales, IPAs, lambics and dozens more) coexist with new and adventurous creations (imperial stouts aged in bourbon barrels, IPAs brimming with fruit essences or turbo-charged with habanero peppers, high-alcohol Belgian-style tripels aged in rum barrels, low-alcohol session beers tailored for pints aplenty).

And where does the Greater Charlottesville region fit into this broader picture? Does it have an identity? Brewers point to the area's natural beauty, its rich history and the community's intellectual vigor as distinctions—Charlottesville has received numerous recognitions as a desirable place to live.

And the beers? Jacque Landry, former brewer at South Street and now head brewer at Basic City in Waynesboro, said, "When I think of craft beer in Charlottesville now, I think of it like craft beer everywhere—people want

the next big thing. I think there's cohesion in terms of loving the craft, but I don't think everybody's trying to do the same thing. I think everybody's trying to do their own thing."

John Bryce, formerly at Starr Hill and now a consultant and owner of the Lupulin Exchange, echoed those thoughts. "Most of the breweries in the area have their own personality of some kind, doing their own thing. But I'd like to think it has a pretty good reputation for quality. I think that most of the breweries in this area are making good beer."

So, an army of small, independent entrepreneurs is revolutionizing an industry through the pursuit of happiness, one pint at a time. I think Thomas Jefferson would approve.

Chapter 12

BEYOND THE BREW HOUSE

Places to drink, places to eat, places to explore, places to learn and places to stay connected—here's a look at some of the options.

Beer Run

Special places connect in ways that sometimes are hard to explain. Your favorite beer bar might not be the one with the most taps, the most exotic selections, the trendiest food or the hippest staff. Or maybe it has all of those things. You keep coming back, though, to a place where you feel comfortable in your own skin, where there's something you know you like and something you know you'd like to try.

I've been going to Beer Run for years. I like the nachos, the people, the lack of pretense, the thoughtful array of beers on tap and the guest tastings every Wednesday. I also know there's always something new—a bourbon barrel-aged stout or a cask-conditioned IPA—to try.

Plenty of other people, it seems, plug into Beer Run in a similar way. Since opening in 2007, it has won multiple "best bar" awards from *C-Ville Weekly*, and *Draft* magazine included it in its list of the country's best beer bars. The main criterion was to walk out of a place saying, "Now there's a bar that really, really cares about your experience with beer."

Beer Run in Charlottesville hosts weekly beer tastings, including this one by Joe Hallock of Chaos Mountain Brewing in Callaway. *Photo by Lee Graves.*

The conviviality and care reflect the family background of Beer Run. Mary Ann Parr, Josh Hunt (her son) and John Woodriff (her stepson) put their heads together in 2007. Parr, whose background in the hospitality business includes owning and operating the Virginian, the iconic tavern on The Corner, originally proposed opening a bottle shop on Carlton Road. "I intuitively felt that area would be a good place to sell beer," Parr said. The economy was starting to go south, so "it was very risky to open up then. We started getting in as much craft beer then as we could."

The concept of a bottle shop quickly expanded to offering draft beer and food. That played to Hunt's strength—he had worked as a bartender in Austin, Texas, and was a homebrewer. With chef Hernan Franco, who had worked with Parr previously, preparing the food, Beer Run quickly became a destination for serious beer lovers. The fourteen taps included Founders' Kentucky Breakfast Stout and Boulder Beer's Hazed and Infused Ale, as well as Pabst Blue Ribbon. "We always wanted to have inexpensive options for people but not necessarily the big macro stuff," Hunt said.

In the bottle shop these days, classics such as Saison Dupont and Duvel share shelf space with cutting-edge breweries like Dogfish Head and Oskar Blues. The tap list is equally diverse. National Bohemian ("Natty Boh," if you're in the know) might be on the same menu with Green Flash Cellar 3 Series Natura Morta Saison (brewed with spices and aged in red wine barrels with cherries). Oh, and there's plenty of presence for locals, even a Beer Run collaboration with Blue Mountain Brewery (an amber ale amply hopped with Pacific Rim hops). There are plenty of wine and cider options as well.

The menu shows a similar balance of familiar and flair. The nachos I love now vie with Salmon Bánh Mì for punching my meal ticket. Sunday brunch is a C'ville institution, with the Classic Southern Biscuits and Gravy Platter, Allagash Fish Tacos (with homemade tortillas) and more.

In 2015, the folks at Beer Run opened a second Charlottesville enterprise, Kardinal Beer Hall and Garden on Preston Avenue. Situated in a Coca-Cola building dating to 1939, Kardinal has a more European, "Alpine-inspired" feel, with goodies such as Munich's Paulaner Salvator Doppelbock and the definitive Weihenstephaner Hefeweizen rubbing elbows with American standards such as Bell's Two Hearted Ale and Firestone Walker Easy Jack—plus nearly a dozen local ciders and beers.

COURT SQUARE TAVERN

Speaking of things European, Court Square Tavern on Fifth Street serves to remind people that America's craft beer boom is not the be-all and end-all of brewing. From Spaten Lager to Fuller's ESB, Pilsner Urquell and Guinness Stout, beers with centuries-old pedigrees headline the draft list. As for bottles, there aren't many places in town where you can get a cold Belhaven Scottish Ale (really from Scotland) or a true Rauchbier from Bamberg.

"When I started out, there was no American microbrewery movement," owner Bill Curtis told *C-Ville Weekly*. "I'm not anti-local or anti-American microbrew, but I do harbor a grudge for making the traditional market sort of marginal."

A sense of tradition pervades the tavern. The building operated as a hotel from 1926 to 1974. Curtis, who also owns Tastings on Market Street, opened Court Square Tavern in 1976 in the basement space, formerly the Hunt Room. Although one American craft beer—Anchor Steam from San

Francisco—was around then to put on his tap list, Curtis obviously takes pride in having a stable of staples these days rather than the latest in barrel-aged IPAs. The low-ceiling, lived-in coziness of the tavern creates an old-world ambience reflected in menu items like Shepherd's Pie and Ploughman's Platter. Or how about a "Best of the Wurst" selection featuring knockwurst, weisswurst, baurnwurst (a smoked sausage) and, of course, bratwurst?

Piedmont Virginia Community College

Beer enthusiasts in the Central Virginia area can take their passion to a professional level, thanks to classes at Piedmont Virginia Community College. In the spring semester of 2015, PVCC's Workforce Services began offering a certificate program in craft brewing. The curriculum comprises nine classes that include an introduction to beer and brewing, the process of brewing beer, brewery design and equipment, growing hops, beer marketing, introduction to barley and malting and even homebrewing.

Classes have been taught by many of the local professionals, ranging from Hunter Smith, owner of Champion Brewing Company, to Cory Hall, barley expert extraordinaire at Wood's Mill Malt House.

Cideries

Virginia's most historic apple, the Albemarle Pippin, is well-represented at Albemarle CiderWorks, off U.S. 29 south of Charlottesville. But its Royal Pippin, a single-varietal offering with notes of pineapple and grape, is but one of a dozen ciders produced on the farm. Others include a citrusy Jupiter's Legacy—named after one of Jefferson's house servants, not the Roman god—a champenoise-style Brut D'Albemarle and a sweetish traditional blend called Ragged Mountain (an area Edgar Allan Poe allegedly roamed while a student at UVA).

The cidery grew from the purchase of property, later named Rural Ridge, in 1986 by Bud and Mary Shelton. Initial plantings, done in collaboration with expert Tom "Professor Apple" Burford, led to an expanded orchard and, in 2009, the cidery itself. The business is definitely a family affair, with several of the Sheltons having key roles. You can often

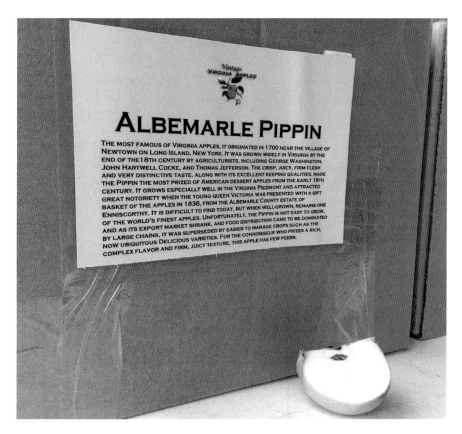

Albemarle CiderWorks makes good use of the Albemarle Pippin, the "most famous of Virginia apples." *Photo by Lee Graves.*

find live music—sometimes impromptu sessions by local musicians—in the tasting room, which features a stone fireplace, spacious views of the countryside and outdoor seating for suitable weather.

In Nelson County, Bold Rock Hard Cider anchors an enviable spot between Wild Wolf and Devils Backbone brewpubs on state Route 151. One of three Bold Rock locations, this is the flagship site and provides cider aficionados with an expansive, rustic setting with a ski-lodge-meets-working-farm feel. The business began in 2012 with a partnership between Virginia native John Washburn and a New Zealand farmer, Brian Shanks. Bold Rock has plugged into the craft beer boom with ciders such as IPA (India Pressed Apple) made with a blend of five hops. The backgrounds of Washburn and Shanks are reflected in Bold Rock Pear, a blend of New Zealand pears and Blue Ridge apples. Outdoor lovers can hike along trails by the South Fork of

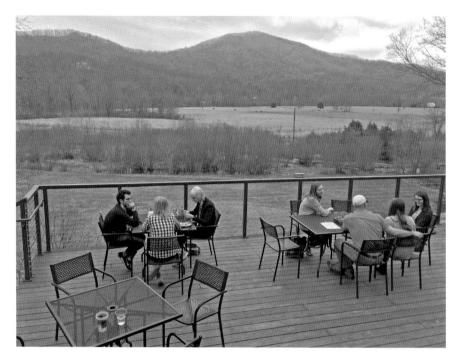

Scenery is part of the appeal of Nelson County destinations such as Bold Rock Hard Cider on state Route 151. *Photo by Lee Graves.*

the Rockfish River or just soak up the scenery in one of the numerous deck and patio spaces by the tasting room.

Just up the road, BLUE TOAD HARD CIDER TASTING ROOM AND EATERY offers seven brands of cider, all from apples grown at Silver Creek Orchard in Tyro and pressed at Winery Lane. The pub—which opened in November 2015 under the ownership of Todd Rath, Greg Booth and Scott Hallock—is managed by Zee Zimmerman, a Charlottesville native who returned to the area after pursuing her education in Florida. The business also has three locations in New York State.

Yet another distinctive niche is being carved out by POTTER'S CRAFT CIDER northwest of Charlottesville. Begun by two homebrewing buddies—Tim Edmond and Dan Potter—the enterprise began with home-based experiments with apples after a flood wiped out their efforts to grow barley and hops at Tuckahoe Plantation (yes, that Tuckahoe). "It was an afterthought," Potter told me. "When we tried it, it was kind of revelatory."

With Wildair Farm in Free Union as their base, they began producing ciders using apples from farms in the region and were growing twenty trees

with plans for nine hundred more. Like Bold Rock, they used hops for two of their signature offerings: Hop Cider, featuring whole-leaf Citra and Amarillo hops, and Mosaic Hop Cider, single-hopped with Mosaic. They're also using brettanomyces, a wild yeast, in raspberry and peach ciders.

Although they're not trying to be historically accurate in their recipes, Potter said that he and Edmond fully appreciate the historic nature of the Albemarle Pippin, Virginia Winesap and other varieties. "We have really good apples in Virginia. We think we have the best apples in the country, in terms of what's available commercially," Potter said.

Castle Hill Cider is crafted on an estate in Keswick that dates to 1764 and boasts of a young Thomas Jefferson playing on the grounds. The tasting room opens to an octagonal porch for outside sampling in agreeable weather. The seven offerings include Celestial, made from a blend of Bittersweet and Albemarle Pippin apples; Black Twig, featuring Black Twig heirloom apples aged in charred Tennessee whiskey barrels; and Levity, the flagship sparkling cider aged and fermented in clay amphorae called kvevri.

Beer Distributors

Three major beer distributors serve the Charlottesville region.

Blue Ridge Beverage Company, founded in 1938, has been owned and operated by the Archer family since 1959. The company acquired Cavalier Beverage Company in Charlottesville in 1984; additional acquisitions have expanded its distribution area to forty-nine counties in Virginia. Blue Ridge carries MillerCoors products, as well as several craft brands, including Charlottesville's Champion Brewing Company, Wild Wolf Brewing Company of Nellysford and Seven Arrows Brewing Company of Waynesboro. In May 2016, the company announced that it would be distributing beers from Oregon's Deschutes Brewery, which plans to build a brewing facility in Roanoke.

Virginia Eagle Distributing, which has six locations in the state, is the largest distributor of Anheuser-Busch InBev products in the Old Dominion. Founded in 2005, the company serves more than fifty localities and carries products from several Virginia craft breweries, including Charlottesville's South Street Brewery, Blue Mountain Brewery and Apocalypse Ale Works in Forest. The company's president, Kenny Wheeler Jr., is son of Kenneth Wheeler Sr. and the late Sallie Busch Wheeler, who lived at Keswick. She

was the only child of the late Catherine Milliken Busch and Adolphus Busch III, as well as the niece of August A. Busch Jr., brothers who built Anheuser-Busch into the world's largest brewing conglomerate.

SPECIALTY BEVERAGE, based in Rockville, Virginia, was founded in 1991 by Bobby Roberts and acquired by L. Knife and Son Inc. in 2009 and then by Reed's Incorporated in 2010. Its portfolio includes Ballast Point and Green Flash, both of San Diego, California (Green Flash has a facility in Virginia Beach).

Trinkin

Begun in Richmond in 2014, the website Trinkin.com was conceived as a mobile website to pair seekers of good beers with places to enjoy them. Within two years, the enterprise had expanded from four to seven employees and entered markets in most of the major cities and towns in the state. "Charlottesville, while still a relatively small market for us, is definitely a city that knows its beer and seeks out the best available," said Andy Frank, one of Trinkin's founders. Breweries like Champion and restaurants like Sedona Taphouse use the site to alert Trinkin "buddies" to what's available, what's nearby, what's on the food menu and even how to link to a taxicab service.

Charlottesville Beer Elite

This Facebook group requires approval to join, but all you have to do is ask. With more than nine hundred members, it serves as an essential forum for comparing notes on beers and breweries, posting events and discussing industry trends (www.facebook.com/groups/554631861250190/10878089 01265814/?notif_t=group_activity¬if_id=1459257886925782).

Charlottesville Brew Tour

Run by Blue Ridge Wine Excursions, this part of the touring business highlights the breweries in Charlottesville, on the Brew Ridge Trail and

beyond. Options include accommodating groups of various sizes—up to thirty-two at once (http://www.blueridgeexcursionsunlimited.com/private-brew-tour).

CVILLE HOP ON TOURS

Another mobile application (on wheels, that is), Cville Hop On Tours drives groups of up to fourteen people to distilleries, cideries and wineries in addition to area breweries. Tours are packaged to focus on various routes in the city and neighboring counties to highlight craft beverages (http://cvillehopontours.com).

EVENTS AND FESTIVALS

As part of Virginia Craft Beer Month, the VIRGINIA CRAFT BREWERS FEST has been held each August at the Devils Backbone Basecamp Brewpub & Meadows in Nelson County. In the past, the event included the Virginia Craft Brewers Cup, where the state's craft breweries vie for medals in various beer style categories; that ceremony was moved to Richmond in 2016 (http://vacraftbrewersfest.com).

The Charlottesville KNOW GOOD BEER (KGB) FESTIVAL is held in the winter and spring and highlights beers from local, regional and national craft breweries (www.knowgoodbeer.com).

The TOP OF THE HOPS BEER FEST is held in the fall, usually September, at the Sprint Pavilion. The event includes a "brew university" with sessions on beer styles, ingredients and food pairings (www.topofthehopsbeerfest.com/charlottesville).

Local breweries schedule numerous smaller events celebrating new beer releases, Oktoberfest, St. Patrick's Day and similar occasions.

BREWERIES AND BREWPUBS IN THE CHARLOTTESVILLE REGION AND BEYOND

Apocalypse Ale Works
www.endofbadbeer.com
(434) 258-8761
1257 Burnbridge Road, Forest, VA 24551
@endofbadbeer

Basic City Beer Company (scheduled to open in 2016)
www.basiccitybeer.com
Phone number not yet available
1010 East Main Street, Waynesboro, VA 22980

Blue Mountain Barrel House
http://bluemountainbarrel.com
(434) 263-4002
495 Cooperative Way, Arrington, VA 22922
@BlueMtnBrewery

Blue Mountain Brewery
www.bluemountainbrewery.com
(540) 456-8020
9519 Critzers Shop Road, Afton, VA 22920
@BlueMtnBrewery

Champion Brewing Company
www.championbrewingcompany.com
(434) 295-2739
324 Sixth Street Southeast, Charlottesville, VA 22902
@championbeer

C'Ville-ian Brewing Company
www.cvillebrewco.com
(434) 328-2252
705 West Main Street, Charlottesville, VA 22903
@CvilleBrewCo

Devils Backbone Brewing Company
www.dbbrewingcompany.com
Basecamp Brewpub & Meadows
(434) 361-1001
200 Mosbys Run, Roseland, VA 22967
Outpost Brewery & Taproom
(540) 462-6200
50 Northwind Lane, Lexington, VA 24450
@dbbrewingco

Hardywood Park Craft Brewery (scheduled to open in 2016)
www.hardywood.com
(804) 420-2420
1000 West Main Street, Charlottesville, VA 22903
@Hardywood

James River Brewery
www.jrbrewery.com
(434) 286-7837
561 Valley Street, Scottsville, VA 24590
@jamesriverbrew

Loose Shoe Brewing Company
www.looseshoebrewing.com
(434) 946-BEER
198 Ambriar Plaza, Amherst, VA 24521

Pro Re Nata Farm Brewery
www.prnbrewery.com
(434) 823-4878
6135 Rockfish Gap Turnpike, Crozet, VA 22932
@PRNBrewery

Queen City Brewing
www.qcbrewing.com
(540) 213-8014
834 Springhill Road, Staunton, VA 24401
@qcbrewing

Random Row Brewing Company (scheduled to open in 2016)
www.randomrow.com
Phone number not yet available
608 Preston Avenue, Charlottesville, VA 22903
@RandomRowBeer

Redbeard Brewing Company
www.facebook.com/Redbeard.Brewing/?rf=264752783663638
(804) 641-9340
120 South Lewis Street, Staunton, VA 24401
@RedbeardBrews

Seven Arrows Brewing Company
www.sevenarrowsbrewing.com
(540) 221-6968
2508 Jefferson Highway, Waynesboro, VA 22980
@sevenarrowsbrew

Shenandoah Valley Brewing Company
www.shenvalbrew.com
(540) 887-2337
19 Middlebrook Avenue, Suite 300, Staunton, VA 24401
@shenvalbrew

South Street Brewery
www.southstreetbrewery.com
(434) 293-6550
106 South Street West, Charlottesville, VA 22902
@SouthStBrewery

Stable Craft Brewing
http://stablecraftbrewing.com
(540) 490-2609
375 Madrid Road, Waynesboro, VA 22980
@stablecraft

Starr Hill Brewery
www.starrhill.com
(434) 823-5671
5391 Three Notched Road, Crozet, VA 22932
@StarrHill

Three Notch'd Brewing Company
www.threenotchdbrewing.com
(434) 293-0610
946 Grady Avenue, Charlottesville, VA 22903
@ThreeNotchdBeer

Wild Wolf Brewing Company
www.wildwolfbeer.com
(434) 361-0088
2461 Rockfish Valley Highway, Nellysford, VA 22958
@WildWolfBeer

Wood Ridge Farm Brewery (scheduled to open in 2016)
www.facebook.com/WoodRidgeFarmBrewery
(434) 531-7362
151 Old Ridge Road, Lovingston, VA 22949

Cideries

Albemarle CiderWorks
www.albemarleciderworks.com
(434) 979-1663
2545 Rural Ridge Lane, North Garden, VA 22959
@AlbCiderWorks

Blue Toad Hard Cider Pub & Tasting Room
www.bluetoadhardcider.com
(434) 996-6992
9278 Rockfish Valley Highway, Afton, VA 22920
@BTHardCider

Bold Rock Hard Cider
www.boldrock.com
(434) 361-1030
1020 Rockfish Valley Highway, Nellysford, VA 22958
@BoldRock

Castle Hill Cider
http://castlehillcider.com
(434) 296-0047
6065 Turkey Sag Road, Keswick, VA 22947
@castlehillcider

Potter's Craft Cider
https://potterscraftcider.com
(850) 528-6314
Free Union, VA (no tasting room yet)
@PottersCider

Charlottesville-Area Restaurants and Taphouses

This is a partial list of destinations that have significant selections of craft beer. Unless otherwise noted, most also offer bottled beer, wine, cider, food and spirits.

Basil Mediterranean Bistro & Wine Bar
www.basilmedbistro.com
(434) 977-5700
109 Fourteenth Street Northwest, Charlottesville, VA 22903
Extensive selection of European beers

Beer Run
http://beerrun.com
(434) 984-2337
156 Carlton Road #203, Charlottesville, VA 22902
@BeerRunVA
More than fifteen taps with extensive bottled beer selection

Citizen Burger Bar
http://citizenburgerbar.com/charlottesville
(434) 979-9944
212 East Main Street, Charlottesville, VA 22902
@citizenburger
More than one hundred beers and ciders on draft and in bottles

Court Square Tavern
http://courtsquaretavern.com
(434) 296-6111
500 Court Square, #305, Charlottesville, VA 22902
@CourtSquareTav
Eight beers on tap, including craft and European specialties; more than 130
imported and American bottled beers

Fry's Spring Station
www.frysspringstation.com
(434) 202-2257
2115 Jefferson Park Avenue, Charlottesville, VA 22903
@FrysSpringPizza
Eight beers on tap

Hurley's Tavern
www.hurleystavern.com
(434) 964-2742
315 Rivanna Plaza Drive, Suite 100, Charlottesville, VA 22901
@hurleystavern
Twenty beers on tap

Jack Brown's Beer & Burger Joint
www.jackbrownsjoint.com
(434) 244-0073
109 Second Street Southeast, Charlottesville, VA 22903
@jackbrowncville
Four beers on tap, extensive bottled selection

Kardinal Beer Hall and Garden
http://kardinalhall.com
(434) 295-4255
722 Preston Avenue, Charlottesville, VA 22903
@KardinalHallVA
More than twenty beers on tap, extensive bottled selection

McGrady's Irish Pub
http://mcgradyspub.com
946 Grady Avenue #16, Charlottesville, VA 22903
(434) 293-3473
@mcgradyspub
Twenty-four beers on tap

Mellow Mushroom
http://mellowmushroom.com/store/charlottesville
(434) 972-9366
1321 West Main Street, Charlottesville, VA 22903
@MellowMushroom
Thirty-eight beers on tap

Michael's Bistro and Taphouse
www.michaelsbistro.com
(434) 977-3697
1427 University Avenue, Charlottesville, VA 22903
Ten beers on tap

Miller's Downtown
www.millersdowntown.com
(434) 971-8511
109 West Main Street, Charlottesville, VA 22902
@MillersDowntown
Sixteen beers on tap at downstairs bar; eight more at upstairs bar

Sedona Taphouse
http://www.sedonataphouse.com/#!charlottesville/c20d8
(434) 296-2337
1035 Millmont Street, Charlottesville, VA 22903
@STHCville
Fifty beers on tap

Staunton Abbey Taphouse
www.thestauntonabbey.com
(540) 712-7300
2221 North Augusta Street, Staunton, VA 24401
Twelve beers on tap and an extensive bottled selection

Timberwood Grill
http://timberwoodgrill.com
(434) 975-3311
3311 Worth Crossing, Charlottesville, VA 22911
@timberwoodgrill
Twenty-four beers on tap

World of Beer
http://worldofbeer.com/Locations/Charlottesville
(434) 970-1088
852 West Main Street, Charlottesville, VA 22903
@wobcville
Fifty-plus beers on tap

Beer Stores

Market Street Wine Shops
http://marketstreetwine.com
Downtown:
(434) 979-9463
311 East Market Street, Charlottesville, VA 22902
Uptown:
(434) 964-9463
305 Rivanna Plaza Drive, Suite 102, Charlottesville, VA 22901
@MarketStWine

Rio Hill Wine and Beer
www.discountvino.com
(434) 295-8466
1908 Rio Hill Center, Charlottesville, VA 22901

Appendix

Wine Warehouse
www.winewarehouseinc.com
(434) 296-1727
1804 Hydraulic Road, Charlottesville, VA 22901

Homebrewing Resources

Fifth Season Gardening Company
http://fifthseasongardening.com/stores/charlottesville
(434) 293-2332
900 Preston Avenue, Charlottesville, VA 22903
@5SCVille

Pints O' Plenty
http://pintsoplenty.com
(434) 851-5646
1219 Burnbridge Road, Forest, VA 24551
@Pints_o_plenty

Miscellaneous

Charlottesville Brew Tour
http://www.blueridgeexcursionsunlimited.com/private-brew-tour
(434) 531-5802
175 South Pantops Drive, Suite 108, Charlottesville, VA 22902

Cville Hop On Tours
http://cvillehopontours.com
(434) 218-3565
1934 Asheville Drive, Charlottesville, VA 22911
@HoponCville

BIBLIOGRAPHY

Books

Alexander, James. *Early Charlottesville: Recollections of James Alexander, 1828–1874. Reprinted from the Jeffersonian Republican.* Charlottesville, VA: Albemarle Historical Society, 1942.

Alexander, Phillip Bruce. *History of the University of Virginia, 1819–1919: The Lengthened Shadow of One Man.* Vol. 4. New York: MacMillan Company, 1921.

Barefoot, Coy. *The Corner.* Charlottesville, VA: Howell Press, 2001.

Baron, Stanley. *A History of Beer and Ale in the United States.* Boston: Little, Brown & Company, 1962.

Britton, Rick. *Albemarle & Charlottesville: An Illustrated History of the First 150 Years.* San Antonio, TX: Historical Publishing Network for Albemarle County Historical Society, 2006.

Child, Samuel. *Every Man His Own Brewer: Or, a Compendium of the English Brewery.* Reprint, N.p.: Colonial Printer & Bookbindery, 2015. Originally published in London, 1798.

Combrune, Michael. *The Theory and Practice of Brewing.* London: Vernor and Hood, 1804. Originally published in 1762.

Craughwell, Thomas J. *Thomas Jefferson's Crème Brûlée: How a Founding Father and His Slave James Hemings Introduced French Cuisine to America.* Philadelphia, PA: Quirk Books, 2012.

Dabney, Virginius. *Mr. Jefferson's University: A History.* Charlottesville: University of Virginia Press, 1981.

Ellis, William. *The London and Country Brewer*. London: J&J Fox, 1735.

Gordon-Reed, Annette. *The Hemingses of Monticello: An American Family*. New York: W.W. Norton & Company, 2008.

Hatch, Peter J. *A Rich Spot of Earth: Thomas Jefferson's Revolutionary Garden at Monticello*. New Haven, CT: Yale University Press, 2012.

Hyland, William G., Jr. *Martha Jefferson: An Intimate Life with Thomas Jefferson*. Lanham, MD: Rowman & Littlefield, 2015.

Kern, Susan. *The Jeffersons at Shadwell*. New Haven, CT: Yale University Press, 2010.

Lathrop, Elise. *Early American Inns and Taverns*. New York: Arno Press, 1977.

MacDonald, Paxson Collins, and Cynthia Marie Conte. *A Taste of the 18th Century*. Memphis, TN: Toof Cookbook Division, 2000.

McLaughlin, Jack. *Jefferson and Monticello: The Biography of a Builder*. New York: Henry Holt and Company, 1988.

Meacham, Sarah Hand. *Every Home a Distillery: Alcohol, Gender, and Technology in the Colonial Chesapeake*. Baltimore, MD: Johns Hopkins University Press, 2009.

Moore, John Hammond. *Albemarle: Jefferson's County, 1727–1976*. Charlottesville: University of Virginia Press for the Albemarle County Historical Society, 1976.

Oliver, Garrett, ed. *The Oxford Companion to Beer*. Oxford, UK: Oxford University Press, 2012.

Randolph, Mary. *The Virginia House-Wife, Or Methodical Cook*. N.p., 1824.

Rawlings, Mary. *Early Charlottesville: Recollections of James Alexander, 1828–1874*. Charlottesville, VA: Albemarle County Historical Society, 1942.

Rice, Kym S. *Early American Taverns: For the Entertainment of Friends and Strangers*. Chicago: Regnery Gateway for Fraunces Tavern Museum, 1983.

Schuricht, Herrmann. *The History of the German Element in Virginia*. Baltimore, MD: Genealogical Publishing Company, 1977.

Smith, Gregg. *Beer in America: The Early Years (1587–1840)*. Boulder, CO: Siris Books, 1998.

Stanton, Lucia. *Free Some Day: The African-American Families of Monticello*. Charlottesville, VA: Thomas Jefferson Foundation Inc., 2000.

———. *Those Who Labor for My Happiness: Slavery at Thomas Jefferson's Monticello*. Charlottesville: University of Virginia Press in association with the Thomas Jefferson Foundation, 2012.

Stanton, Lucia, and James Bear, eds. *Jefferson's Memorandum Books: Accounts, with Legal Records and Miscellany, 1767–1826*. Princeton, NJ: Princeton University Press, 1997.

Bibliography

Wiencek, Henry. *Master of the Mountain: Thomas Jefferson and His Slaves.* New York: Farrar, Straus and Giroux, 2012.

Woods, Edgar. *Albemarle County in Virginia.* Charlottesville, VA: Michie Company, 1901.

Wust, Klaus. *The Virginia Germans.* Charlottesville: University Press of Virginia, 1969.

Articles

All About Beer. "Charlie Papazian Discovers Homebrewing and the Rest Is Our History." January 14, 2016.

Brewbound. "Charlie Papazian Takes on New Role at BA." January 5, 2016.

Brew Your Own. "Homebrew During Prohibition." December 1997.

Charlottesville Area Real Estate Weekly. "Business Is Brewing." November 27–December 3, 1995.

Charlottesville 29. "Beer Run." 2013.

Crozet Gazette. "Blue Mountain Brewery Launches Big Expansion." June 2, 2011.

———. "New Brewery Coming Soon to Crozet." April 3, 2015.

C-Ville Weekly. "Against the Grain: C'Ville-ian Brewing's Mea Culpa." June 15, 2016.

———. "Big River: Scottsville's Contribution to the Craft Beer Scene Ups the Ante." March 13, 2014.

———. "Brew Battle: Two Charlottesville Beer Joints Go Head-to-Head." April 24, 2014.

———. "Re-beer-th: South Street Joins the Big Leagues with Striking Renovation, New Beer List." November 19, 2014.

———. "Starr Gazing: Longest Tenured Local Brewery Makes Big Change at the Top." March 5, 2015.

———. "Three Cheers for Three Notch'd: A New Beer Spot Makes Its Mark in the Local Craft Brew Lineup." October 3, 2013.

Daily Progress. "Albemarle Board OKs Much Smaller Growth Area Expansion." October 2015.

———. "Better Beer: Microbrewery Strives for Quality." June 5, 1988.

———. "Big Victory Celebrated." November 1, 1916.

———. "The Cost to Charlottesville." June 3, 1907.

———. "Dry Majority in City." September 23, 1914.

————. "Goes Dry by Forty Votes." June 5, 1907.

————. "Responding to Growing Local Industry, PVCC Now Offers Certificate Program in Craft Beer Brewing." May 22, 2015.

————. "Scottsville's First Brewery Could Open in February." January 7, 2012.

————. "Virginia Dry Midnight Tonight." October 31, 1916.

Denver Post. "Charlie Papazian Reflects on 30 Years of Homebrewing Craft Beer." December 22, 2011.

MidAtlantic Brewing News. "What's Brewing in Virginia." June/July 2015.

NBC29. "Blue Mountain Brewery Purchases South Street Brewery." July 3, 2014.

Newsplex.com. "South Street Brewery Sold, Holds Last Night." July 3, 2014.

Roanoke Times. "Ballast Point Brewing Announces Plans for Brewery at Botetourt's Greenfield." May 24, 2016.

————. "Deschutes to Build Brewery in Roanoke." March 22, 2016.

ONLINE SOURCES

Ingram, David Lee. "History of the Fairfax Line." Virtual Museum of Surveying. http://www.surveyhistory.org/the_fairfax_line1.htm.

Massachusetts Historical Society's Thomas Jefferson Papers. "Farm Book, 1774–1824." http://www.masshist.org/thomasjeffersonpapers/farm.

————. "Garden Book, 1766–1824." http://www.masshist.org/thomasjeffersonpapers/doc?id=garden_53&archive=all&query=hops&tag=text&num=10&rec=5&numRecs=5#firstmatch.

The *Philly* History Blog. "Ground Zero for Philadelphia Beer." http://www.phillyhistory.org/blog/index.php/2011/10/ground-zero-for-philadelphia-beer.

Thomas Jefferson Papers at the Library of Congress. "Volume 1: Household Accounts and Notes of Virginia Court Legal Cases." https://www.loc.gov/item/mtjbib026553.

Thomas Jefferson's Monticello. "African-American Gardens at Monticello." https://www.monticello.org/site/house-and-gardens/african-american-gardens-monticello.

————. "Beer." https://www.monticello.org/site/research-and-collections/beer.

————. "Humulus Lupulus—Hops." https://www.monticello.org/site/plantation-and-slavery/humulus-lupulus-hops.

————. "Jefferson Quotes and Family Letters." http://tjrs.monticello.org.

————. "Joseph Miller." https://www.monticello.org/site/research-and-collections/joseph-miller.

————. "Monticello Brews Jefferson-Inspired Ale." https://www.monticello.org/site/blog-and-community/posts/monticello-brews-jefferson-inspired-ale.

————. "Spring Crop Harvest." https://www.monticello.org/slavery-at-monticello/about/spring-crop-harvest.

Timothy J. Dennée. *Robert Portner and His Brewing Company*. City of Alexandria, Virginia. https://www.alexandriava.gov/uploadedFiles/historic/info/archaeology/SiteReportDenneePortnerBreweryHistoryAX196.pdf.

Waynesboro Historical Commission. "The Founding of Basic City, Virginia to Its Merger with Waynesboro, Virginia 1890–1923." http://www.visitwaynesboro.net/DocumentCenter/View/79.

OTHER SOURCES

This book makes use of numerous magazine, newspaper and online articles written by the author, including those published by the *Richmond Times-Dispatch*, *Richmond BizSense*, *Virginia Business Magazine*, *Virginia Craft Beer Magazine* and *Virginia Golfer Magazine*.

INDEX

ABOUT THE AUTHOR

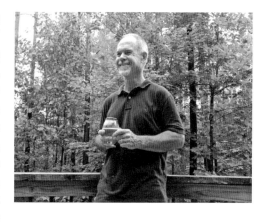

Lee Graves received his baptism into the world of wonderfully diverse beer during a visit to Germany in 1986. From a visit to a monastery where the monks brewed a high-octane schwarzbier to the Hofbrauhaus in Munich, where strangers became friends over brimming liters of lager, he experienced a culture that set him on a lifelong adventure learning about beer. In 1996, while a writer and editor at the *Richmond Times-Dispatch*, he began writing a weekly column about beer; it was syndicated by Tribune Media Services in Chicago for several years. In 2014, his *Richmond Beer: A History of Brewing in the River City* was published by The History Press. A lifelong resident of Virginia and graduate of the College of William and Mary, he continues to write about beer for magazines and his website, www. leegraves.com. He also occasionally homebrews and frequently speaks to community and professional groups. Graves currently splits time between Charlottesville and Richmond, where he lives with his wife, Marggie.